BLACKBURN'S
BIRDS

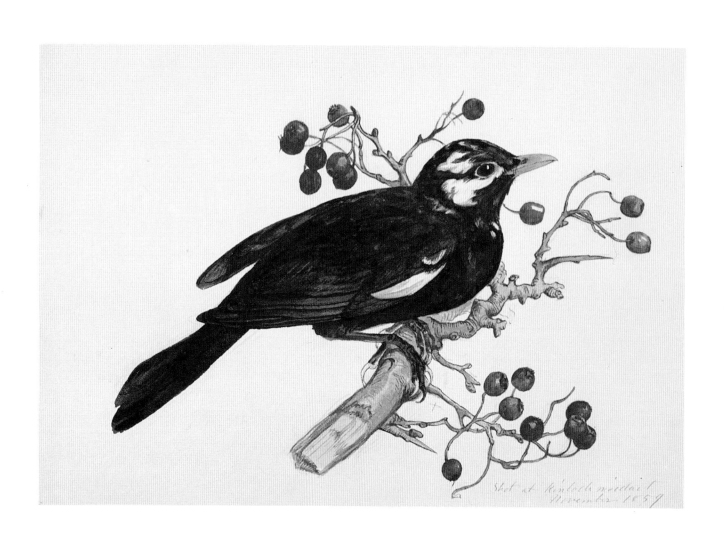

JEMIMA
BLACKBURN

⊁ Blackburn's Birds ⊁

EDITED AND INTRODUCED BY
ROB FAIRLEY

CANONGATE
PRESS

First published in 1993
by Canongate Press Limited
14 Frederick Street Edinburgh EH2 2HB
The Publisher acknowledges subsidy from the Scottish Arts Council
towards the publication of this volume.

—

—

ISBN 0 86241 436 9
British Library Cataloguing-in-Publication Data
A catalogue record for this book is available on request
from the British Library

—

Frontispiece: Pied Blackbird
Designed and typeset in Adobe Caslon by Dalrymple
Printed by Ebenezer Baylis & Son
Worcester

⭑ ACKNOWLEDGEMENTS ⭑

I WAS still at school when I first came across the name of Jemima Blackburn. Before a school trip to the island of St Kilda in 1968 the pupils involved were handed an extensive reading list. Usually I consigned such items to a wastepaper basket but in this case my eye spotted Hammond Innes's *Atlantic Fury* crouched at the foot of the page. This was unusual, the school's English department did not, in those days, encourage the reading of 'popular' fiction. My curiosity aroused I read the book and then, to my surprise, worked my way through the rest of the list until only one item remained. This obscure volume was called *How the Mastiffs went to Iceland.* Rather ominously, it was by Anthony Trollope, a name that often appeared on English department reading lists. When I eventually tracked a copy down in the National Library I found it was, as I had expected, a rather dull read, however I did notice the quirky illustrations by a Mrs Hugh Blackburn. A few days later I was in Mrs MacNaughton's bookshop at the top of Edinburgh's Leith Walk and took the opportunity of asking her if she ever saw copies of *The Mastiffs* and if she knew anything about Mrs Blackburn. She replied by asking if I had ever seen Mrs Blackburn's ornithological books and reaching into a glass-fronted bookcase produced a copy of *Birds from Nature.* The illustrations were superb but so very different in style from the Trollope book that I doubted they were by the same person. Mrs MacNaughton however assured me they were.

At that point adolescence, exams, art college and a plethora of other things intervened leaving the information lying dormant and on the periphery of memory for many years. One day about ten years ago when I was working on the hill with Alan Blackburn, a close friend and neighbour, he told me that his great-grandmother used to paint ... I showed little interest, since becoming a professional painter I had discovered that everyone has, or has had, a relative who paints. Some weeks later he eventually persuaded me to have a look at the work in question. We walked up the road to his mother's house, then taking an oil lamp (electricity is a relatively recent arrival) we climbed the stairs to the library. Alan went to a cabinet, took out a red leather album, opened it then almost immediatly closed it again explaining that it was not the one he wanted to show me. There are moments in life when the concept of Time being a constant seems ridiculous. This was one such. As the book closed I realised that I had seen these pictures before. Alan had not had time to replace the album before I realised that what he was holding were the original paintings for *How the Mastiffs went to Iceland.* At that moment something of an obsession was born.

Over the years many people have given freely of their time to help with my research and a wee mention here seems a poor way of recording my real, and very grateful thanks. Without the support of the Blackburn family the project would have foundered very early on. Pauline Blackburn provided the initial spur and her enthusiasm ever since has been a source of inspiration. Alan and Mary-Anne Blackburn have obviously been involved with my researches from the start. Indeed the majority of the illustrations in this book come from the collection of Alan Blackburn.

Without their enthusiastic support and friendship this book could not exist. Nigel and Nicki Blackburn who have let me wander through their beautiful house at will, Ninian Blackburn, Jamie Blackburn, Felicity Blackburn, Catriona Blackburn, Charlotte Blackburn, Margaret Blackburn, Alison Blackburn, Hugh Blackburn, Andrew Blackburn, Michael Blackburn, Vicky Smith, Toni and Robert Maclean, Elizabeth Grey, and Veronica Parker have all provided much useful information.

I have been greatly helped by many people who have allowed me to view their Blackburn paintings or who have written providing valuable information, in particular: Sir John Barran, the late Jean Burns, Patrick Bourne, Karen Brennan, David Black, John Busby, Ursula and John Bowlby, Mrs Cameron-Head, Sir John and Lady Clerk, John Dye, Mr and Mrs R. I. Fairley, Dr R. I. Fairley, Dr Prof. R. V. Jones, Maureen and Lionel Lambourne, the late 'Ton' Macdonald, Angus Peter Maclean, Donald Macrae, Bob MacGowan, Hugh Marwick, Lady Delia Millar, Mary Noble, Alison Peaker, John Reid, Howard Radcliffe, Luke Richardson, Michael Robson, Nino Stewart, Sebastian Thewes, Iain Thornber, Prof. Ivan Tolstoy, and the late Brigadier Wedderburn-Maxwell.

The staff of the British Museum Print Room, The British Library, the British Museum of Natural History, the Collins Gallery, Glasgow University, the National Library of Scotland, the Royal Museum of Scotland, the Royal Library and the West Highland Museum have all provided efficient and valuable help.

The photographic work of Alex Gillespie and Neil Maclellan helped save this book suffering an 'eleventh hour disaster' and Siobhán Edgar cheerfully gave up large parts of her holidays to help sort slides.

Finally my thanks to my wife Fiona who has helped decipher manuscripts, read and re-read proofs and has had to live with every aspect of this book and the research surrounding Jemima Blackburn for many years. Not once has she objected to this other woman in my life.

Rob Fairley *Lochailort, July 1993*

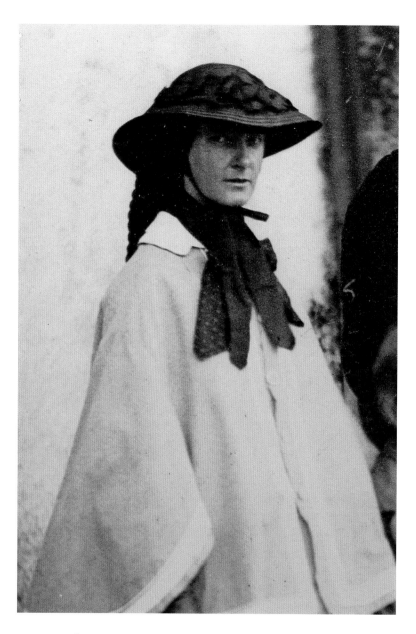

Jemima Blackburn, 1857, ambrotype by Hugh Blackburn

REPUTATION is a fickle and tenuous commodity. Its survival often seeming to be based on some quirk of fate rather than on a lifetime of serious and honest endeavour. The relentless hands of time have consigned many renowned figures to a quiet and forgotten limbo. Jemima Blackburn's reputation faded with the passing of the Victorian age. She had been one of the most popular and innovative of its artist illustrators and had been particularly admired for her ornithological studies. Her neglect stems in part, from the fact that the majority of her work was published in black and white, making it readily affordable to her admirers but inevitably leading to it being eclipsed by the fine coloured work of artists like Lear, Wolf and Gould. In recent years there has been a growing recognition of her importance. This has been led initially by the discovery of her extraordinary visual diary: thousands of exquisite watercolours which give a vivid day by day account of her life, and latterly by the recognition of the role she played in the history of illustration. This book shows for the first time a comprehensive selection of what she considered to be her most important work, namely her bird paintings.

Jemima Blackburn was born in Edinburgh in 1823 the seventh child of James Wedderburn, Solicitor General for Scotland. As a girl she was delicate and received much of her education at home. She also taught herself and like the Renaissance artists she drew as she studied. There can not have been too many young Victorian women who dissected small animals so as to find out how their bones and muscles worked. Nor can there have been many who could (or would) have persuaded the Professor of Anatomy at the Royal College of Surgeons to give her private lessons. Her passion for natural history was insatiable. As a child she preferred to keep a Pigeon in her doll's house, and had as one of her most constant companions a Raven named 'Beelzebub'. She completed a woodcut of two pet owls when she was only sixteen, a picture which shows a mature and quite phenomenal talent as a draughtswoman. All her life she combined this skill with a capacity for intelligent observation and an acute, almost photographic, visual memory. By the time she was twenty Landseer could declare that in the painting of animals he had nothing to teach her.

Her first two publications appeared in 1847. Both are versions of traditional tales, stories she must have heard round the fireside on many a winter's evening. She went to tremendous pains to ensure that the illustrations appeared as she wished, drawing the lithographic plates herself and producing highly detailed preparatory sketches showing how her drawing would appear when reversed by the printing process. Both volumes were highly successful, quickly sold and established her as an illustrator of some note.

The following year she married Hugh Blackburn, the recently elected Professor of Mathematics at Glasgow University. They had known each other for a long time (Jemima's sister Janet had married Hugh's brother Peter thirteen years earlier) and from the start their marriage was a delightful success and, perhaps unusually for the Victorian era, not in the least intellectually stifling. During their courtship Hugh had

encouraged her to experiment in a wide variety of printmaking techniques including the then avant-garde medium of photography. He had been active in this field for some years, Jemima sketching a photographic session at Killearn a full year before Fox Talbot published an account of his 'invention'. In 1853 Hugh and Jemima collaborated on a small volume *The History of Little Downey*, using the recently invented *cliché-verre* process which involved drawing directly onto a photographic plate. Sadly no copy of this book seems to have survived. The following year she again used photography as a means of reproducing the drawings for her first important publication, the ambitious *Illustrations from Scripture by an Animal Painter.*

With pleasing symmetry the central years of the nineteenth century provide an important philosophical, theological, scientific and aesthetic watershed. The study of nature, in all its many forms, had been seen as being inextricably linked to the study and worship of God. By the late 1850s however the lynchpins of natural theology had begun to crumble. It became impossible to ignore the new European critical methodologies which cast serious doubts on a literal interpretation of the bible. The more naturalists asserted that each natural organism revealed God in all his glory, the more obvious it became to educated men and women that it did not. The pivotal point came in November 1859 with Charles Darwin's publication of *Origin of Species by Natural Selection.*

Blackburn's *Illustrations of Scripture by an Animal Painter* neatly encapsulates this period. It takes the fundamentalist theological viewpoint and illustrates it with a disturbing modernity, using the most sophisticated and modern means of reproduction available. For the most part it is simply a book of natural history drawings which only tenuously illuminate biblical teaching. Ruskin in an achromatic but perceptive review in the *The Morning Chronicle* (Jan 20th, 1855) points out that 'The animals are throughout principal, and the pathos or moral of the passage to be illustrated is developed from its apparently subordinate part in it. Thus the luxury and idolatry of the reign of Solomon are hinted behind a group of "apes and peacocks" [*sic*]; the Deluge is subordinate to the dove; and the healing of the lunatic at Gennesarth to the destruction of the herd of swine.' In many ways it is reminiscent of the period when for an artist to paint landscape it was deemed essential to add the figure of a saint or angel thus making it an acceptable religious picture. Blackburn's next book was to have no such duality.

The middle of the nineteenth century can be seen as the high point in the history of the illustrated ornithological book. It was a period when scientific research involved listing and classifying, a time before photographic means of reproduction had become commonplace and when it was economically possible to have a large skilled workforce capable of hand-colouring the thousands of prints required for an edition of even modest size. Prideaux John Selby and John James Audubon set themselves the enormous task of depicting life size all the species of birds in their respective countries. Selby's *Illustrations of British Ornithology* was issued in nineteen parts between 1819 and 1834 showing 280 species in 218 plates. Audubon took twelve years to produce his *Birds of America* which comprises four volumes containing 435 prints, eventually completing it in 1838. The work of both men however was overshadowed

by a younger figure. John Gould, organiser, designer, salesman, general manager and entrepeneur *par excellence* was responsible for producing eighteen large and exquisite folios illustrating the birds of the world. These consist of 2,999 different images each produced lithographically and each hand-coloured. At the height of his fame more than a thousand individuals, institutions and libraries subscribed to at least one of his books. Gould employed many of the country's best illustrators, notably Edward Lear (whose *Illustrations of the family Psittacidae* is in my opinion the greatest of all bird books) Joseph Wolf and H. C. Richter. The colouring of the lithographed plates was done by out workers, often working in family groups receiving between 3d. and 9d. per illustration depending on the detail required.

These fine books were very much luxury items which only the rich could afford, a market which did not appeal to Blackburn. She agreed with William Swainson who wrote that he hoped that Gould would '… reprint those expensive volumes in such a form they may be accessible to naturalists: and thereby diffuse science, instead of restricting it to those only who are wealthy'. Accordingly when she came to plan her own contribution to the genre she decided that it should be issued with black and white illustrations, thus keeping the price at a reasonable 10/6. Many of the illustrations were taken from existing paintings. In each case the image being carefully redrawn in black and white so as she could judge the final look. More unusually several of the pictures were drawn directly onto the lithographic stone (or zinc plate) in the field. It is some testimony to her skill that it is impossible to detect the field prints from the studio ones without access to her sketch books … and even then there is room for doubt. *Birds from Nature* was ready for publicaton in 1862 when some 'eleventh hour disaster' occurred which led to the destruction of some of the plates. Blackburn was touring in the Middle East at the time and when hearing of the news wrote home to her husband '… I wish the book had gone right, it is such a bother after telling so many people about it – it's coming to nothing but she is too far away to give any advise [*sic*] about it – but [must] go ahead with her foreign sketches …'. On her return she decided that the book should be published in an attenuated form and was pleasantly surprised to find it met with immediate enthusiastic public and critical acclaim. 'We have seen no such birds since Bewick's. We say this not ignorant of the magnificent plates by Selby, Audubon, Wilson and Gould …' wrote *The Scotsman* critic.

Always something of a perfectionist Blackburn was never happy with the book and immediately began to plan a second edition. When it was eventually completed in 1868 twenty-two additional plates had been added, which typically she insisted be sent free to subscribers and purchasers of the 1862 edition. She can only have been delighted with the second edition for it is a beautiful book. Six copies were coloured by hand for sale to the general public and a further one produced as a birthday present for a special friend. In its coloured form *Birds from Nature* is one of the rarest and most desirable of all British Bird books. It also received high praise from the critics, *The Athenæum* deciding that '… these are among the most perfect and conscientiously executed works we have ever met with'. *The Scotsman* published a long and verbose review:

When some portion of this splendid and interesting volume was published two or three years ago, we found the difficulty of conveying by any words of praise or description, an adequate idea of its impressive yet unobtrusive beauty; and now, however willing, we can neither repeat nor improve upon our former failure. The peculiarity of the drawings is, that, besides being exquisite in skill and taste, they are made from life and nature and not from books and museums. They are both delightful as mere picures and instrucive as faithfull exhibitions, not merely of the shapes and proportions of the birds but of their haunts and habits. Above all they represent not the species merely but the individual – not a bird but the bird. Mrs Blackburn instead of having her subjects brought to her dead or even captive, has sought them out in their own homes, and has depicted them and their habits as they live – as they run or fly, strut or creep, soar or dive. Their homes, too, have been carefully studied and are pleasantly and accurately represented – we have not only interiors, but landscapes and this renders the Natural History of the book more natural than Natural History often is – bringing to us the freshness of the shore, the wave, the wood, and the moor. Then in drawing either a single person or family Mrs Blackburn does not, as the manner of others is, draw a mere average Gull or Goshawk, or an average nest full of Ouzels or Sandpipers – as a painter would do if he put up something claiming to represent only a 'man' or 'a woman' or 'two children'. Mrs Blackburn gives us distinct, spirited, faithful portraits of each bird that has sat to her. She is especially successful where success might seem most difficult in giving individual expression to the eyes and bills and even tails of young. Look at those two infant Black Guillimots … each one of them exhibits a different mental and moral disposition as clearly as the countenance of each of any cluster of children that ever filled a house with glee or a nursery with din. One of the infant Guillimots … is as clearly as expressive of calm resolution and sober dignity; as the other is querulousness and fidgitiness, you can safely predict for one long life; fat, prosperity, for the other a brief and troubled career. There is a portrait of a young gull – taken before he acquired a tail or wing or plumage – which is the very image of ugliness and self satisfacion. What a ruffian in aspect is that young Landrail which seems inclined to defy and bully the world into which it has been only a few minutes born; and thence we get a lesson not to trust too much to appearances for that rough ill shaped and surly little squab will in a few weeks grow into the most handsome gentleman-like, and retiring of all birds as may be seen from the pleasant portrait of his progenitor with which he is contrasted … every plate is a thing to linger on.

Such anthropomorphic verbiage can offend or amuse the contemporary reader, however the writer does show a clear grasp of what was different in Blackburn's work to that of her predecessors. She did go to great lengths to draw and paint 'the individual', on occasions navigating deep pools in a washing tub in order to reach a nest, or sketching an owl from the steps of a ladder. She was also the only bird painter of her time to step outside the genre and be influenced by the world of Fine Art. Looking at the illustrations of Gould and his stable it is difficult to see any signs of the Pre-Raphaelite revolution that swept through British Art during the middle years of the century. The Ruskinesque credo of 'truth to nature' should have had profound

implications for their work but was seemingly ignored by all except Blackburn.

Joseph Wolf a fellow professional also noted this break with tradition and wrote her a long congratulatory letter. He was one of the leading members of the Gould team and an important and influential artist in his own right .

London, 59 Berners St., Jan. 11 1868.

Dear Madam,

I beg to apologise for the long delay in aknowledging [sic] the receipt of your beautiful book of 'Birds' which arrived here some time ago. I have been away in Germany to assist in settling some family affairs in consequence of the death of my mother.

I thank you very much for this handsome present & I need not say that I am greatly delighted with it, for I have long since admired what I have seen of JB conscientious & truthful work.

The heads and expressions of your birds are particularly good & true & what I have always liked in your drawings of horses and other animals - the legs and feet - are here also good, which can only be the result of close and careful study. With regard to your backgrounds of foliage & I must say that it is not easy to make such careful work suitable as a background, but you have succeeded well by giving graceful stalks & leaves in outline & by putting in a touch of depth only where required. In avoiding hard outlines of single feathers & over-precision of their markings you have preserved an agreeable breadth & have produced pictures of birds as birds are generally seen. The reverse of this subordination of detail forms a great fault in Gould's drawings; his pastel plumage without light shade or perspective in the markings spoils the form by flattening it and instead of showing the round body of a bird it often looks more like a mere map of its markings. Besides as Mr Gould has never drawn birds direct from the life his figures must be more or less conventional & consequently there are very few of them so characteristick [sic] as those of yours which are done direct from the life and it is only the deplorable state of general ignorance in the matter even among naturalists which stands in the way of making this apparent at a glance. In birds most people look for the colour, few see the actual form & this leads me to think that for a larger sale of your book coloured copies would perhaps be more suitable than plain ones. I shall of course avail myself of every opportunity to recommend your 'Birds' as I have here said they deserve & I trust that their own merits will ultimately make them as popular.

I wish you success with your marmosets. I know monkeys are generally bad sitters & I fear they will give you much trouble.

I was sorry that you did not see my pictures of last summer when they were finished. The water was difficult & would have been more so had I not introduced a bank with Fir trees in the middle distance to assist me by their reflection. Since then I have done four large cartoons in charcoal for Earl Grosvenor's place in Sutherland-shire. I had them photographed (11 by 7½ inch) and as soon as the light gets better to have a good set of them printed I shall do myself the pleasure of forwarding one to you. In the meantime I send the same subject here on a small scale which will give you an idea of the subjects.

Yours very truly, J. Wolf

Critical acclaim was not limited to this country. A correspondent of Professor Blackburn wrote from Montreal '… allow me to tell you it is Mrs B's *Birds from Nature* (the coloured copy) that is admired by everyone I have shewn [*sic*] it to, all agree it is the finest work of the kind they have ever seen.'

Scientifically Blackburn's most significant contribution to ornithology was her proof of the nesting behaviour of the fledgling cuckoo. I do not intend to give the full story here as it is told at some length in her own words on pages 65–6, suffice it to say that Darwin refers to her account in the sixth edition of *Origin of Species* and Gould had a lithograph of her drawing made and inserted as corrigenda to his *Birds of Great Britain*. What is extraordinary is that Blackburn chose to publish the information first not in a scientific paper or journal but in the illustrations to a popular but rather poor narrative poem written for children, *The Pipits* (1871).

Her last major book, *Birds from Moidart*, proved to be her most popular. It was planned to be part of a complete Moidart avifauna but although the majority of the illustrations and parts of the manuscript were completed the project suffered from Hugh's painstaking research methods. His work on the mollusca, crustascae and in particular the Naked eyed Medusa of Loch Ailort promised much, but sadly was never completed. The illustrations for *Birds of Moidart* are mostly taken from *Birds from Nature* with the addition of several new plates which had been made in the intervening thirty years. It is a book which perhaps more than any other has contributed to the fading of Blackburn's reputation. The illustrations are poorly reproduced and often use drawings which, with hindsight, are very far from her best work. Its text will not appeal to the scientific ornithologist, being mainly anecdotal. Her original observation and research was rarely published and this to the contemporary reader, is the great weakness of Blackburn as an ornithologist. In her day it was one of her great strengths, the general public were not as well informed as they are today and science, even then, required its populisers. She was however a far more rigorous observer than her publications would testify and many of the surviving paintings are liberally annotated with field notes as to size of specimen, number of eggs etc. The professional bodies took her work seriously, Harting writing from the Linnean Society to congratulate her on the appearance of 'your handsome volume'.

Birds from Moidart was published in 1895 and by then a younger woman was beginning to make her mark in the self-same areas that Blackburn's reputation had been made. Beatrix Potter is of course best remembered for Jemima Puddleduck, Squirrel Nutkin and the rest of her menagerie of childhood characters. She was also however a naturalist of some importance, her work on fungi being particularly noteworthy. The two women met only once, on Friday June 5th 1891, Potter recording the occasion in her journal.

Went to Putney Park this morning and was very much interested to meet Mrs Blackburn – she was apparently on a few days' visit, and leaving this afternoon, so her sketch book was unluckily packed up. However, I don't know that I altogether regretted it as she may possibly be getting old as regards her drawing, and her personality was quite sufficiently amusing. I have not been so much struck with anyone for a long time. I was of course strongly prepossessed and curious to make her

acquaintance, but she is undoubtedly a character, apart from her skill – unless indeed there is anything in a theory I have seen – that genius – like murder – will out – its bent being simply a matter of circumstance.

I remember so clearly – as clearly as the brightness of rich Scotch sunshine on the threadbare carpet – the morning I was ten years old – and my father gave me Mrs Blackburn's book of birds, drawn from nature, for my birthday present. I remember the dancing expectation and knocking at their bedroom door, it was a Sunday morning before breakfast. I kept it in the drawing room cupboard, only to be taken out after I had washed my grimy little hands under that wonderful curved brass tap, which, being lifted, let loose the full force of ice – cold amber – water from the hills.

The book was bound in scarlet with a gilt edge. I danced about the house with pride, never palled.

I consider that Mrs Blackburn's birds do not on the average stand on their legs as well as Bewick's, but he is her only possible rival. Certain plates, notably the young Herring Gull and the Hoody [sic] Crow, are worthy of the Japanese ...

She is a lady of apparently over sixty, not tall, but with a very sturdy, upright presence, and rather striking features. In fact, in spite of the disadvantage of an ancient billy-cock hat and a certain pasty whiteness of complexion suggestive of ill health, I thought her a handsome lady.

Her hair was becoming noticeably white, particularily the eyebrows, her nose aquiline, sharp black eyes, a firm mouth with thin lips, and strong hands. Her voice was strong and pleasant, she spoke with a Scotch accent, and with just sufficient Scotch assurance and abruptness to be quaint without being harsh.

Her manner was very alert and noticing, well assured, but in no way aggressive, (she made no direct reference to her drawings). She gave me the impression of a shrewd, practical woman, able and accustomed to take the lead in managing a family estate ... It must be understood that I do not in the least mean to imply that Mrs Blackburn is all matter of fact without sentiment. She is a broad, intelligent observer with a keen eye for the beautiful in nature ... Altogether I carried away the impression of a kindly, chatty old lady, with a keen common-sense and a large fund of humour, capable of deep feeling, but in the meantime heartily enjoying an encounter with an an enragèd muscovy duck.'

The influence of Blackburn on Potter is marked, the younger woman copied from *The Pipits* when a girl but even in later life there are surprising similarities, particularly Potter's illustrations for *Little Red Riding Hood*, 1894, which show the strong influence of Blackburn's 1870 publication *The Cat's Tale*.

Birds from Nature, 1868, marks the high point of Blackburn's published work. Fine though it undoubtedly is, it does not do full justice to her paintings. Handcoloured lithographs can be beautiful but they can not have the freedom of brush or pencil on paper. The majority of the illustrations in this book are taken directly from Mrs Blackburn's paintings and show for the first time her astonishingly varied and painterly technique. Late studies like the Nightjar or Fulmar are freely painted on thick rough brown paper, the texture of the feathers being achieved by the dexterous dragging of a semi-dry brush across the paper. During the productive mid-period,

1855–68, she used a meticulous network of tight brush strokes on white paper often glazing on over body colour to achieve images of startling reality. Her early work is in traditional watercolour sometimes heightened with skillful pen work. Occasionally she would cut out a painting of a bird and glue it to a different background or use several cut-outs in a collage, the Willow Warbler is a fine example of this method of working (sadly the acid in the glue she used has seriously damaged some of these collages, this being most obvious in the Blue Tits). Her technical skill when coupled with her characteristically strong and idiosyncratic sense of design present us with images of startling power and subtlety. Her Guillemot with its lithe draughtsmanship extraordinary composition and fluid accurate use of pigment ranks as one of the most original bird paintings of any age. Many of the illustrations in this book have not been published before, some were probably never meant for public viewing. The Oystercatcher was prepared for the 1862 edition of *Birds from Nature* and then mysteriously never revived. The beautifully delineated Tern, House Sparrow and many others were done for no commercial motivation and drawn purely as a means of 'knowing it better'. I have also taken the liberty of reproducing some of her preparatory sketches (she probably would not have approved) which show her consummate draughtsmanship and the uncanny ability to capture the essence of a bird in a few deft lines.

EDITORIAL NOTE

The illustrations which follow are in the same order as Mrs Blackburn uses in *Birds from Moidart*, which roughly follows that used by Yarrell whose 1856 three volume set of *A History of British Birds* was Mrs Blackburn's definitive handbook. The text, which she wrote herself, casts a fascinating sideways glance at the science of ornithology a hundred years ago and is edited from both editions of *Birds from Nature*, *Birds from Moidart* and several unpublished manuscript sources. I have taken the liberty of making the spelling of the birds' names consistent throughout.

⊰ PREFACE ⊱

THE PICTURES of birds in this book are all drawn from nature, most of them from life, and, when that was not feasible, from fresh killed specimens placed in the attitudes and with the surroundings such as I have seen when they were alive. I have always been interested in birds. The first book I ever possessed was a copy of Bewick's *British Birds*, given to me when I was four years old, and I should be very glad to think that this work of mine might give to others, even in a small degree, the pleasure that book gave to me – that it might lead them to consider the fowls of the air as capable of affording delight in other ways besides filling a game bag, or adorning a hat.

I do not attempt to give a complete collection of British birds, still less to describe them scientifically, but only to represent such birds as I have known personally, and to add simply, and I trust truthfully, a few observations which I had the opportunity of making on their life and habits.

It is proper to explain that Roshven, which is given as the locality of some of our birds is in the district called Moidart which constitutes the South West corner of Inverness-shire. It lies on the South shore of the sea loch, Loch Ailort, which is itself a branch of Loch n Nuagh [sic] both of which are mentioned.

JEMIMA BLACKBURN

SEA EAGLE

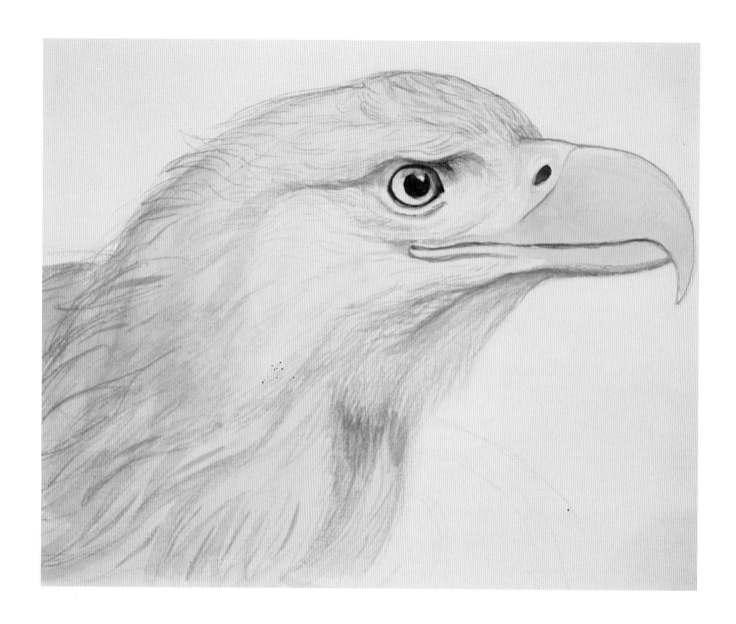

THE illustration is from a sketch of a young full-grown bird belonging to the Duke of Argyll, which was afterwards sent to the Zoological Gardens. Its eyes were hazel, the plumage is of a more uniform rich chocolate brown, and the eyes are yellow. It is rarer here than the Sea Eagle, but I have seen it occasionally – once flying near the coast of Ardnamurchan, pursued by Sea Gulls; and another time, perched on a rock at Ardnish. We once found the remains of one in a steel trap lying on the sea-shore. It had probably been caught in the island of Rum, and had flown away with the trap till it fell exhausted into the sea, and was washed ashore on this coast. The Eagle flies low in pursuit of its prey, as the Goshawk does; not pouncing, like the Peregrine, but picking up its prey as it floats along. It is probably too heavy to do otherwise.

A friend of mine saw one skimming along a hillside and swooping up a lamb nest, said to be that of a Golden Eagle, on a high cleft of a bare sea-beaten rock at the point of Ardnish. It consisted of a great mass of coarse sticks and heather stalks. It has now entirely disappeared, and has never been replaced.

I sketched two young ones also at Auchendarroch. They were carried to the house with their legs carefully secured, though they were very tame, for even a friendly grip of such claws would be serious. They use their claws mostly in attacking their prey, and the beak afterwards to tear it in pieces. They were let loose in the servants' hall, and, rather to our terror, began flying round the room over our heads. Finally, they settled down on the table, and feasted on some rabbits which had been provided for them.

Sketching eagle young at Auchendarroch, 21.11.1859

It is a remarkable thing that the beaks of all birds – be they Eagles or Finches, Curlews, Avocets, Parrots, or Pelicans, or even the Spoonbills – however differently formed for feeding purposes, should all serve equally well for preening their feathers.

Eagles have been known to attack and destroy red deer. The following account has been sent to me by an eye-witness, Allan McLaren, deer stalker to Lochiel. He writes as follows:

December 21, 1894.

On one of my rounds on Ben-e-chrie, about the month of March, twelve years ago, I noticed about forty hinds coming along the face of the hill at full gallop, and, wondering what disturbed the animals, I sat down, thinking they were pursued by a dog. But taking out my glass, I observed three Golden Eagles hunting after the deer, and having about a mile and a half of the hill in view, I watched eagerly what was to be the result. During the last half mile a year old stag broke away from the herd, and one of the Eagles fixed on his back, the other two following close by. Latterly they disappeared out of my sight, about a mile away. I at once made for the spot. On arriving, I found the year old stag killed by the Eagles, and part of him devoured opposite the heart. All three were busily engaged in the feast, having a right jolly dinner. I felt at the moment if only I had a gun – although Eagles were strictly preserved – I could not resist the temptation of having a shot.

Allan McLaren

Capturing an eagle chick

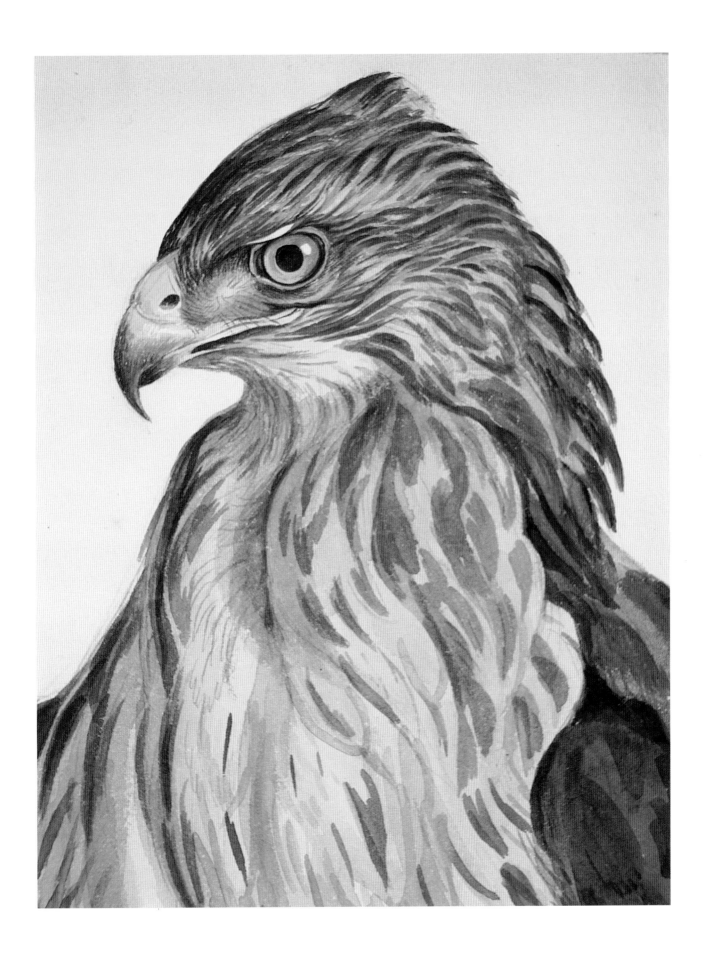

⚜ BUZZARD ⚜

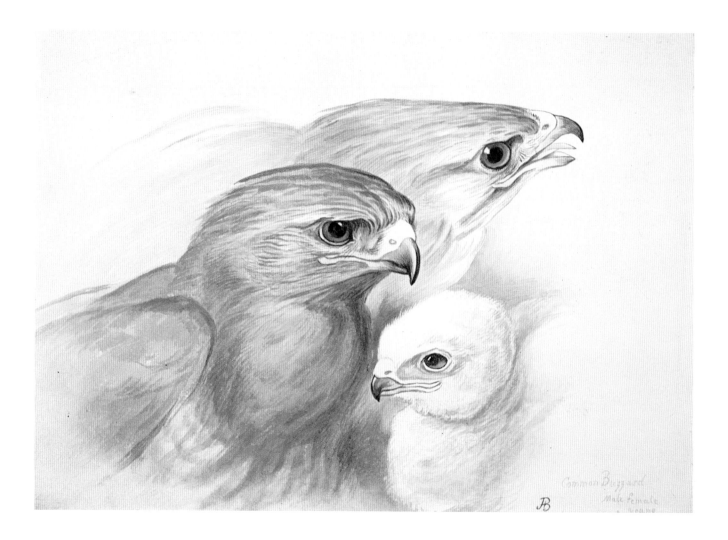

THIS large Hawk is not uncommon here. From its size and broad tipped wings it might almost be mistaken for an Eagle when soaring at distance. Those in the illustration were got from a nest near here. It was a rocky bank, not very difficult of access, rudely constructed of sticks, and containing three young ones, and with remains of hill hares and scraps of small lambs lying about it, rather dirty, and with a powerful smell, which I had to endure while I made a drawing of the nest on the spot.

Buzzards are sometimes erroneously called 'Kites'. I have never seen the really fork-tailed kite in this country, except at the zoo. They are very numerous in Egypt, and very tame and bold. They are very fond of fish. I have seen them hovering over fishermen who were netting a small canal, and trying to snatch the fish from them. The Glead is another name for the Kite, also for the Buzzard.

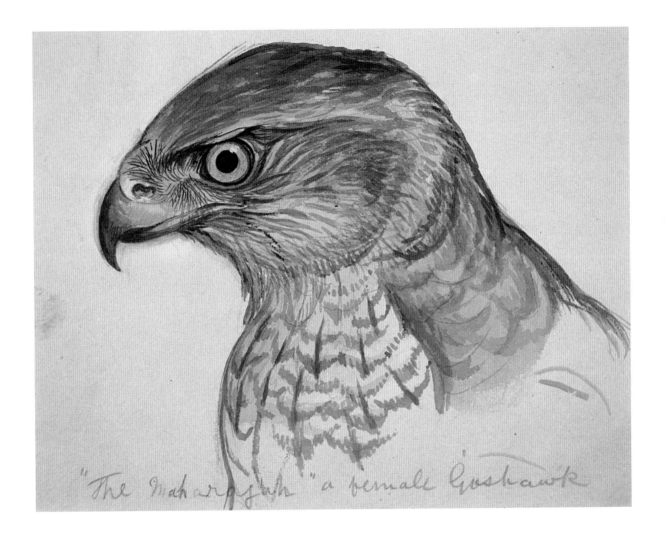

"The Maharajah" a female Goshawk

DRAWN from a trained female bird belonging to Captain Salvin, whose book on Hawking is well known. The attitude is a study from nature.

The Goshawk's manner of pursuing its prey is different from the Peregrine's. It does not soar and pounce, but flies along low, swooping on the victim and carrying it along in its flight as Eagles do.

We went out hawking with Captain Salvin and his Goshawk one winter's day to Garscube, near Glasgow. A hare was soon started. The bird was thrown off, and flew straight after it, but presently changed its mind and flew off into the woods. We had to go in pursuit of it, and spent all the afternoon searching for it, guided by the cries of the little birds, who were much alarmed at its appearance, and sought to drive it away with their noise. We luckily found it and captured it just before dark, and drove back to Glasgow, having acquired some knowledge of the habits of birds, though not much of the sport of hawking. The failure was caused by the bird having been fed too recently, the keeper not knowing in time that it was to be flown that day.

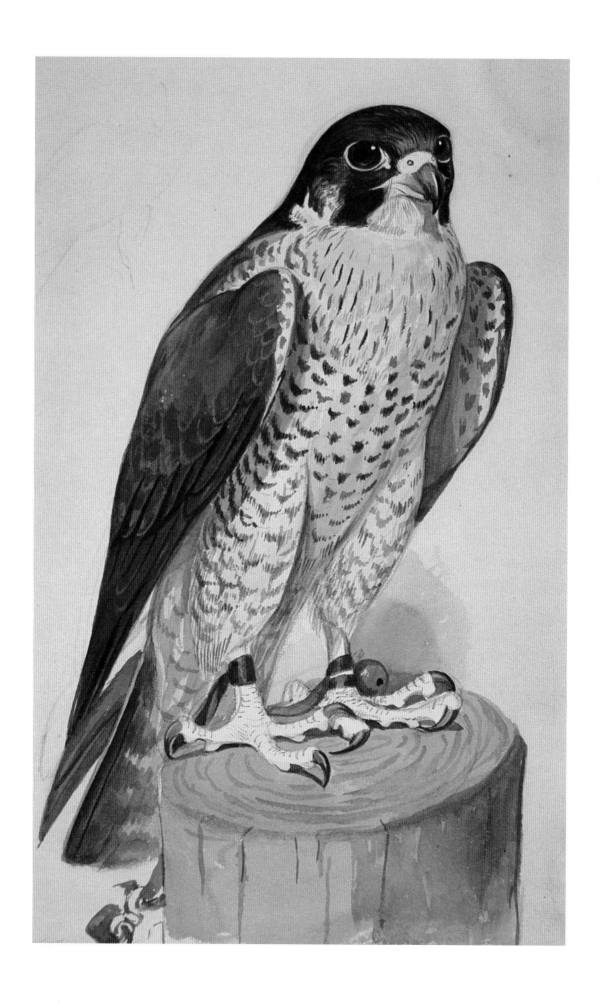

FALCONS are distinguished from hawks by having a tooth-like notch in the beak, and by having more pointed wings, the second quill being the longest in the wing, not the fourth, as in hawks. The Peregrine Falcon is not uncommon in Moidart. The young ones in the illustration were taken from a nest in a wild glen near Loch Ailt [*sic*], not many miles from here, to be reared for a friend who wanted to train them for hawking. We fed them mostly on young Rooks which were being shot at that time. They ate voraciously, and, when gorged, laid their heads down on the carcase [*sic*] and fell asleep.

When Captain Salvin was quartered in Ayr, many years ago, I have seen a falcon of his flown at Rooks for want of better game. The unfortunate Rook it was pursuing always made for the shelter of a hedge or wall, where the Falcon had not room to strike, whence it had to be driven out by the cracking of long whips.

In Ireland Peregrines are frequently flown at Magpies, which afford better sport. On the open plains of India Herons are the best game, and the pastime can be enjoyed on horseback. The most interesting part of all to the uninitiated was to see the Falcon, at the falconer's call, return to the lure of its own free will, submitting to the bondage of hood and jesses, when it had the power to fly away and be at large.

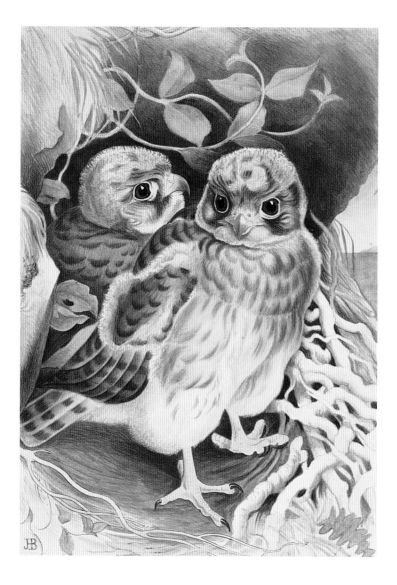

THE Kestrel or 'Windhover', as it is sometimes called, is common here, but not in such numbers congregated together as I have seen in some parts of Europe. Many of them may be seen in Athens hovering over the Parthenon. I saw great numbers flying over the heights above Cherbourg, near the church of Notre Dame de Secours. They had evidently been feeding on Privit Hawk moths, the debris of whose wings was lying on the ground. There is also a colony of them in London. When we were on the top of St Pauls one summer morning waiting to see the sun rise, some Kestrels woke up and began flying about at the first light of dawn, long before either the Pigeons or Sparrows bestirred themselves.

The young Kestrels in the picture were taken alive from the nest and drawn from life. The nest which was on the top of a rock on the island, was also drawn from nature on the spot. The young had still some down on them, though nearly fledged.

The Merlin is also to be seen here, but not so often as the Kestrel.

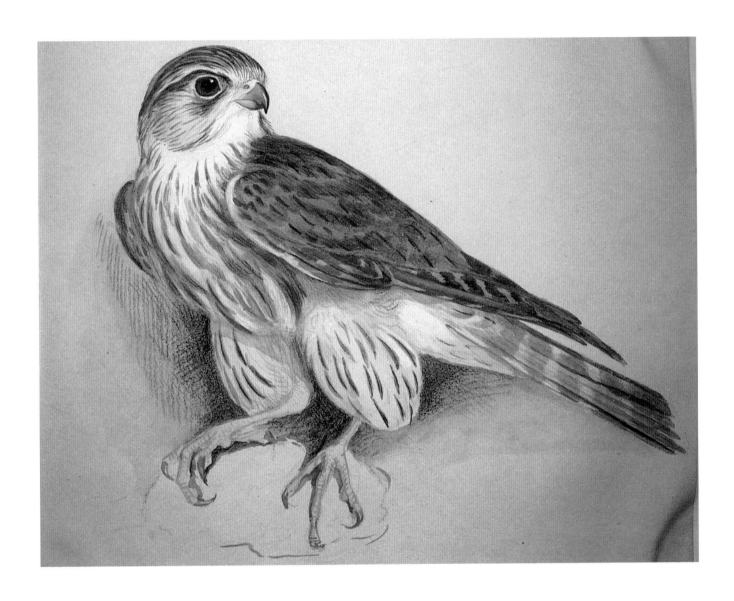

THIS bird is the commonest of its tribe here, and its depredations among domestic fowl render it the most conspicuous. Grave cause have poultry and pigeons 'to curse that hedgerow thief the sparrow Hawk'. Bold, clever, and active, it can wing its way through among the crowded branches in a fir plantation, where it is nearly impossible to get a shot at it, and when arrived at the poultry yard, it cannot be fired at without risking the lives of the chickens. The orphans of the incubator were the first to suffer if ever they ventured beyond the sanctuary of the foster-mother, some of them disappearing daily. After an enclosure was netted safely for them, we again heard an outcry in the poultry yard, and found the Sparrowhawk attacking a brood of chickens under the motherly guardianship of a hen, who was facing it boldly in their defence, and shrieking for help, while the chicks were lying flat on the ground shamming death, not moving a muscle till after they were lifted. At last an order had to be given that the marauder was to be shot at all hazards, which was done, costing the lives of two of the chickens, martyrs to the public safety. Their bodies were hung up over a steel trap as bait for rats or weasels. Next day the trap had disappeared, but a clanking sound was heard on the shingley shore close by, and another Sparrowhawk was discovered caught by the leg drawing the trap after him. Another, which came into a shed after a Blackbird, was adroitly caught and slain, and a family of six were shot in a neighbouring wood, where they had their nest among the trees.

> *Still we're not quit of that prolific race,*
> *For when one falls another fills his place.*

They are very bold birds; audacious enough even to come close to a house in pursuit of their prey. I have known them to pounce through a window to get at a bird in a cage.

One day when feeding my Pigeons a panic seized them, and they flew off with a loud clatter. There was such a cloud of blue feathers filling the air that I could not at first see what had happened. In the course of the day the body of one of the Pigeons was found by the roadside half a mile off, which the Hawk had plucked, and was just beginning to feast on when he was disturbed. The rest of the Pigeons fled. Some flung themselves head-foremost into the dovecot; others 'severed and madly swept the sky', high up in wide circles, too much terrified to take their food that day, nor could they take their meals in peace for many days after.

I have known a Sparrowhawk fly off with a Peachick nearly as big as itself, but, finding it too heavy, had to drop it.

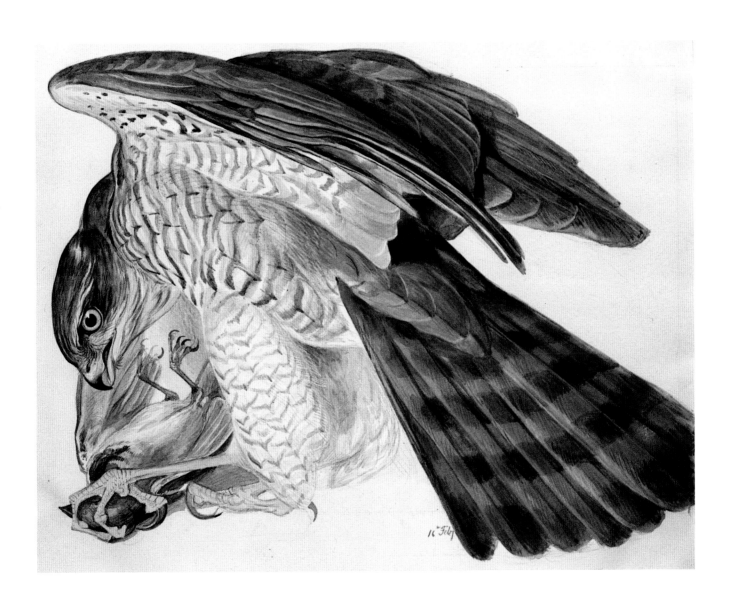

THIS large portrait was from a tame bird. Owls have young ones of different ages, in the nest and outside of it on the branches, at the same time, still being fed by the parent birds. I brought a couple of young ones here, where we had none, though they existed a few miles off, and let them loose in the garden, where they sat on an old tree stump in a cave by day, and were 'mocked and wondered at' by the little birds when they discovered their reteat. They were not old enough to shift for themselves when I first imported them, so we always put out a share of what was caught in the evening, and they always devoured it before morning. We also imported some white Screech Owls, but they have disappeared.

The Tawny Owls have increased, although some of them were shot by a timid neighbour, who thought their hooting foreboded evil, and who did not appreciate the cheerful sound in the bright moonlight nights.

I saw a curious scene in the cave where those imported Owls spent the day. A Wren had discovered their haunt, and was strutting up and down on the stump beside one of them, with its tail so stiffly cocked up as nearly to touch its back. The infuriated little troglodite was screaming defiance in its loudest voice and hurling insults at its sleepy head. The Owl, whether from stupidity or good nature, made no attempt to retaliate.

⚜ LONG-EARED OWL ⚜

SO called from the long ear-like feathers that stand up on its head. Was drawn from a caged bird, a fine, lively, well-feathered specimen, with brilliant yellow eyes. I have never met with it in a wild state, nor with the Short-eared Owl.

✢ BARN OWL ✢

✢ LITTLE OWL ✢

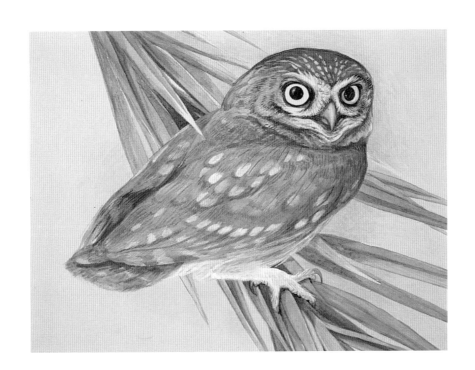

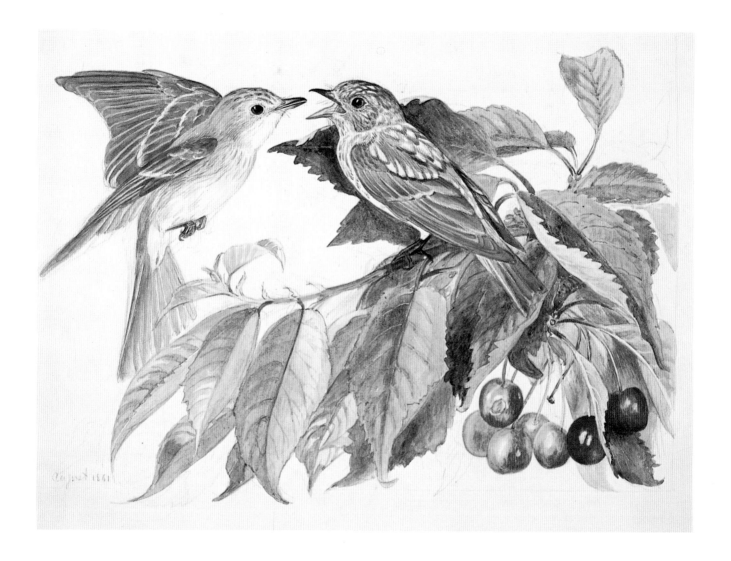

THE plumage in the young bird is much more obviously spotted than in the old. Their song resembles that of the Chats. They perch on a branch or rail, and the old bird flies up after insects, which it catches on the wing, and brings to its young.

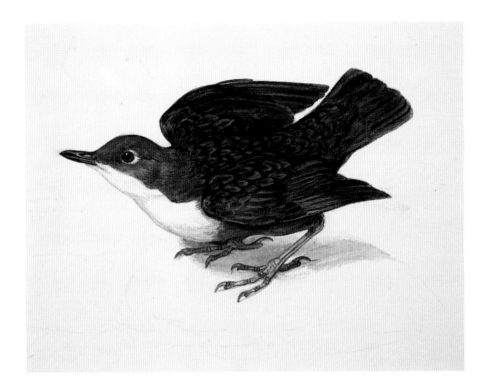

THE Dipper [*above*] is not common in this part of Scotland (I got my specimen in Forfarshire). I do not know if the absence of minnows may have anything to do with that, and with the King fisher [*sic*] being hardly ever seen here. Both are common enough in other parts of Scotland.

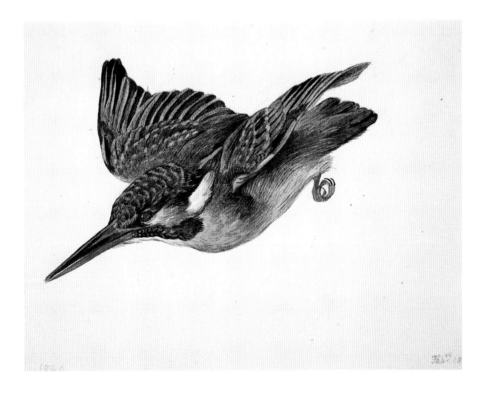

THE Pied Wagtail is more numerous in Moidart than the Grey one (which I should be more inclined to call yellow) it may be seen in winter, especially in the South of Scotland, where it comes to be fed among other hunger-tamed birds at the back door.

Both sorts of Wagtails come much about the windows and roof of Roshven in autumn, seeking for the flies that are beginning to look for their winter quarters.

The Pied Wagtail has the rather poetic name of 'The Seed Lady' among the Catholic peasantry of Braemar. It is supposed to be sent by the Virgin Mary in spring to let them know the proper time to sow the seed.

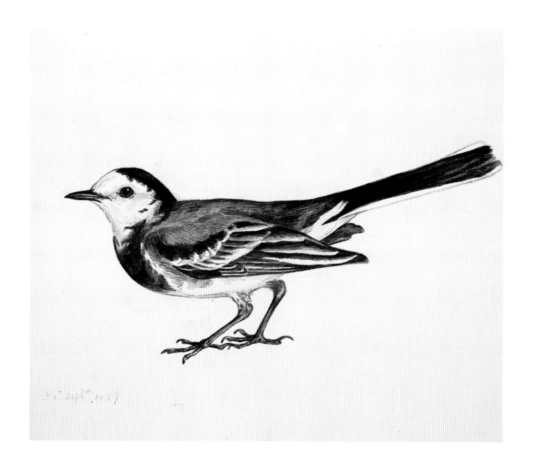

THIS bird [*right*] is very common here. It frequents heathery ground, and is called in Scotland the Moss Cheeper. Gamekeepers find it troublesome in attracting the attention of young dogs, who sometimes stop and point it instead of following after Grouse. It is a dull coloured little bird, with a feeble song which it makes the most of by fluttering up on high like the Skylark. It is most interesting when looked upon as a 'baby farmer' to the Cuckoo, in which compulsory vocation it displays an unwearied and disinterested tenderness, worthy of imitation by the featherless bipeds who, for the mammon of unrighteousness, voluntarily undertake a like office.

Pipits generally lay four speckled brown and white eggs; if there is a fifth, it is suspected by the natives here to be that of a Cuckoo – which suspicion I have not found verified.

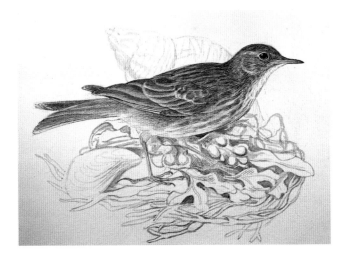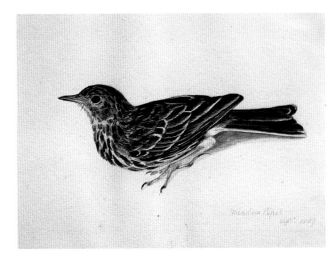

⊰ ROCK PIPIT ⊱

THOUGH not very numerous the Rock Pipit [*left*] is common here. I once found a nest among some low rocks on our island near the shore. It contained some fledged young ones not yet able to fly. They seemed in great terror, as a huge black slug had invaded the nest; with what intent I know not, but probably for no good, for it is carnivorous, as well as a devourer of carrion. I made a sketch of the scene on the spot; having done that, and having no time to wait, I cast out the intruder, to the great relief of the nestlings, but with my curiosity unsatisfied.

I have only once seen a Tree Pipit here and it was brought in by the house cat!

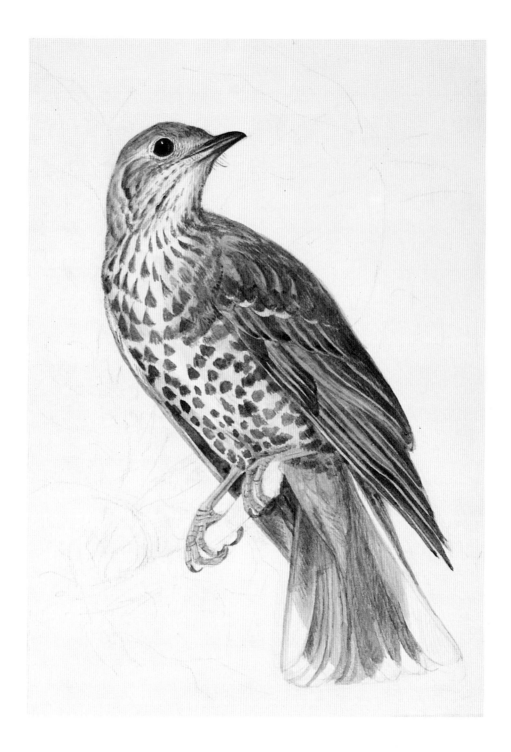

THE Mistle Thrush is one of the largest of its tribe, being two inches longer than the Song Thrush, and of a paler colour.

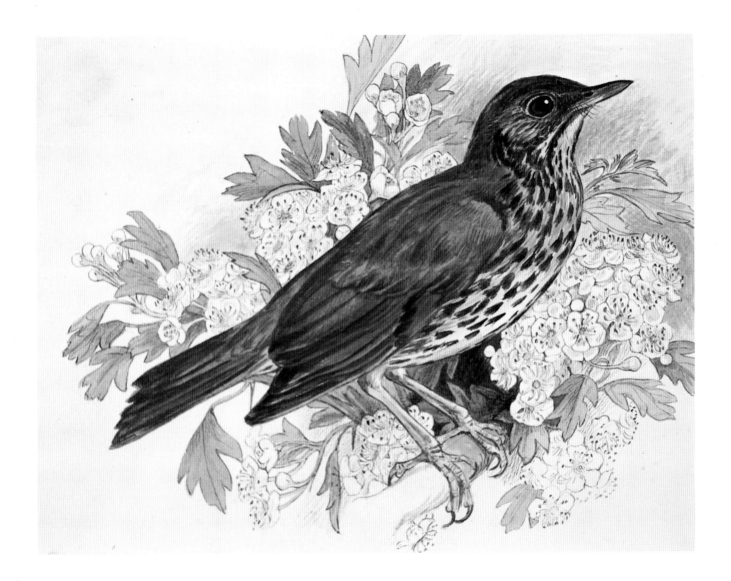

I MADE this drawing from a cage-bird borrowed from a workman in the High Street of Glasgow. Thrushes are much more numerous at Roshven now than they were when we first came, probably owing to the increase of cultivation and enlargement of the garden. They stay all winter, unless the frost be unusually severe, and may be heard singing their most beautiful of all birds' songs even in a January morning if the weather be mild. They sing earlier in the morning and later in the evening than Blackbirds do. Of course, these birds take their full share of the fruit, but that can be replaced by parcel post – the songs cannot. Thrushes abound in summer in the birch woods as well as in the garden here.

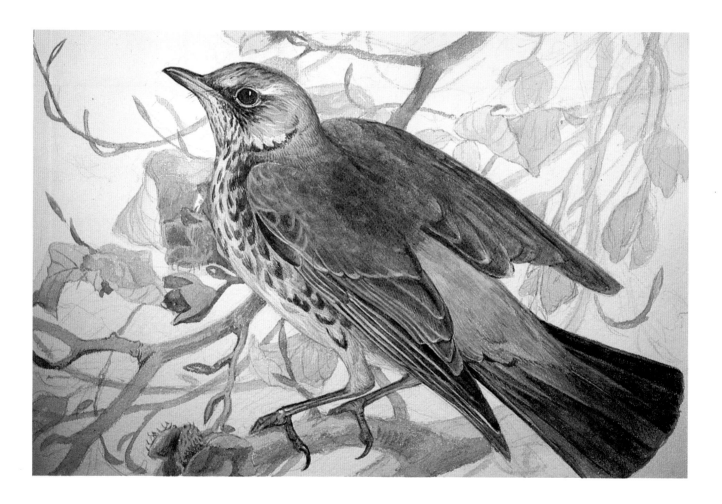

FIELDFARES come in great numbers to all parts of Scotland in autumn, and are generally accompanied by flights of Redwings. They are very fond of rowan berries, and devour great quantities of them. The unusually large crop we had this year (1894) was cleared off by them in a few days and left the trees bare.

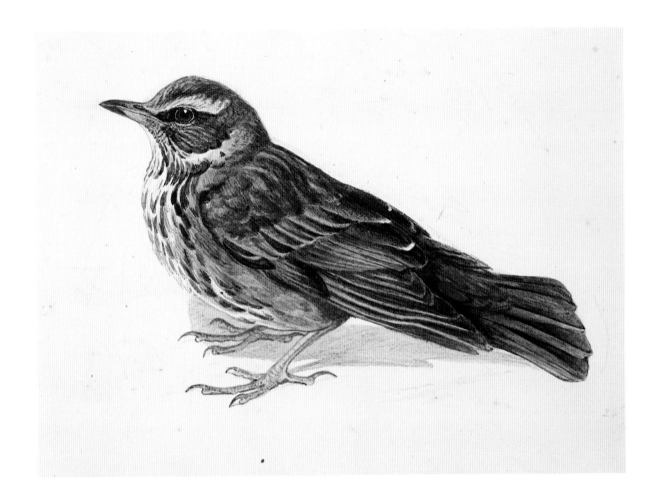

THIS drawing is from a bird caught alive in a feeble and famished state on the snow near Ayr, in the severe frost at Christmas 1860. I have seen them feeding greedily on the berries of the yew tree. They do not seem to be so hardy as Blackbirds, or so able to stand privation, although they come to us from cold countries. I have met with them in Iceland, and heard their pretty thrush-like song.

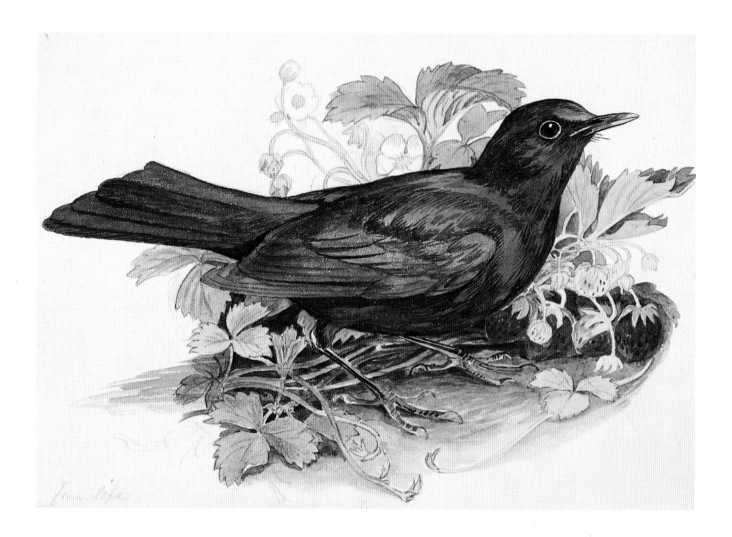

From life

THIS drawing is from a caged bird. The Blackbird is common here, but keeps mostly to the garden. It begins to sing in March, and prefers doing so in an elevated situation – the top of a tree, or even the roof of the house – principally in the afternoon. The female is brown and the young spotted brown; neither have the bright yellow bill of the cock.

The Blackbird finds it a good plan when in search of worms to stamp on the ground, which it does energetically with both feet at a time. The worms, supposing that a mole causes the earthquake, come to the surface.

I used to have difficulty in distinguishing clearly between the song of the Blackbird and the Thrush before I lived so much among them, so I got a young Blackbird and kept it in a cage, that I might know its song better, hoping to hear it 'warble its native wood-notes wild', but was disappointed; it only made feeble attempts to whistle a tune.

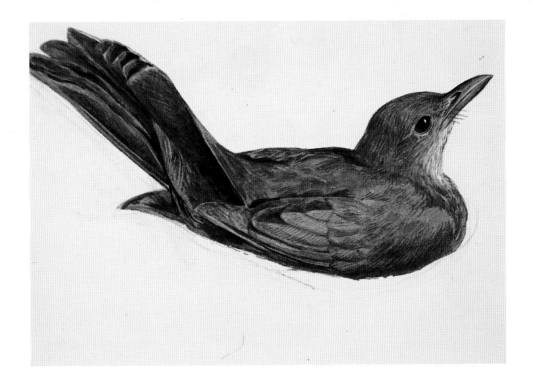

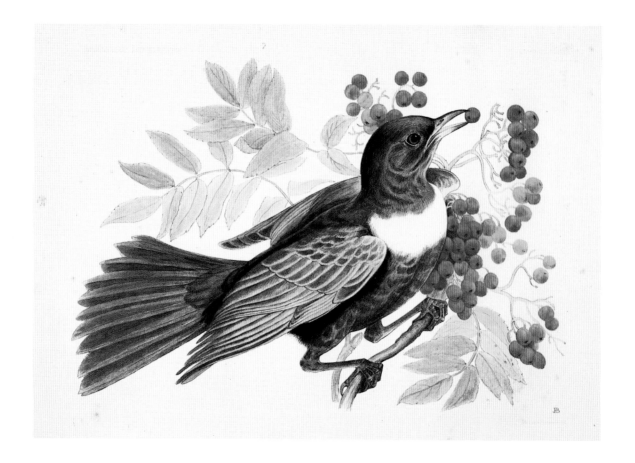

RING ouzels breed in considerable numbers on the hills of Moidart. A number of them come at early morning usually and attack the gooseberries in our garden at Roshven. They all disappear about the end of September. The drawing is from one caught alive after it had been wounded. The mountain ash berries (or rowans), which the bird is represented eating, are a favourite food.

DRAWN from life. The Hedge Sparrow is common here. It sings sweetly, some-times even in winter. It inhabits the garden, and comes to the window for crumbs in hard weather. There were no Common sparrows here when we came first, nor for many years afterwards.

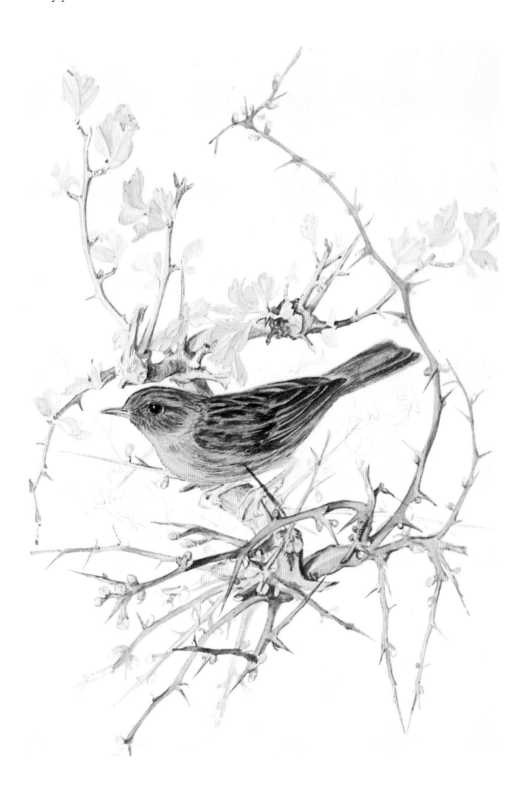

⊁ ROBIN ⊁

ROBINS are very numerous here, and very tame; they frequently come into the house in winter, which necessitates saucers being set with water and crumbs all about the stair case for their convenience. One used to come in at the dining room window daily at breakfast time and hop about the table, selecting what it liked best, principally butter, of which it was very fond, then warbling a little song of thanks. One used to come to the kitchen in winter for butter, and also in summer, carrying off some to feed its young.

One summer (at Doonholm, in Ayrshire) a Robin built its nest in one of the drawing-room curtains, inside where it is looped up. The curtains had to be pushed back every evening to allow the shutters to be shut, but it did not mind that. It reared and took away, I think, six young ones. The next year it built its nest in the footman's hat in the pantry, but unfortunately, the pantry had to be painted, and the hat was hung outside the window, and it deserted. Several Robins used to live in the house in winter; they were very tame, and used to sit on the clock on the drawing room chimneypiece and sing. One of them used always to put itself to bed on the top of the canopy of the bed in one of the spare rooms.

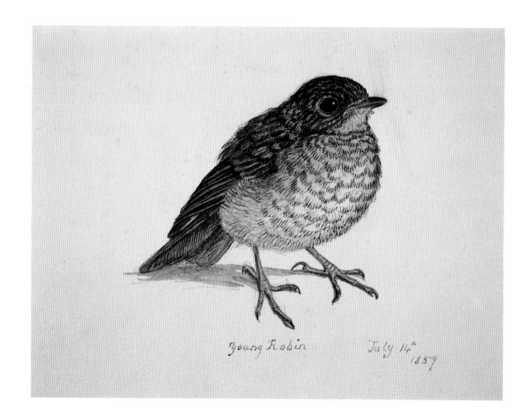

Young Robin July 14th 1857

THE Redstart is common in Moidart in summer. The picture represents the male and female that had a nest in the old garden wall. We first caught the cock alive by placing a piece of net over the hole where the hole was, and when its picture had been taken, and it had been set at liberty, the hen was caught in the same manner. There are many of them about the birch woods as well as in the garden. Firetails they are called in England, from the brilliant appearance of their tails when the birds are flying about insects. The cock is a showy bird, with its red breast and tail and black throat, contrasting with its grey upper part and white forehead. The hen is pale-brown, nearly white on the throat and under parts, the tail red like that of the cock. I have seen some come aboard ship in the Bay of Biscay in rough weather in October. Having already depicted them, I did not care to have them caught. The young are spotted like young Robins.

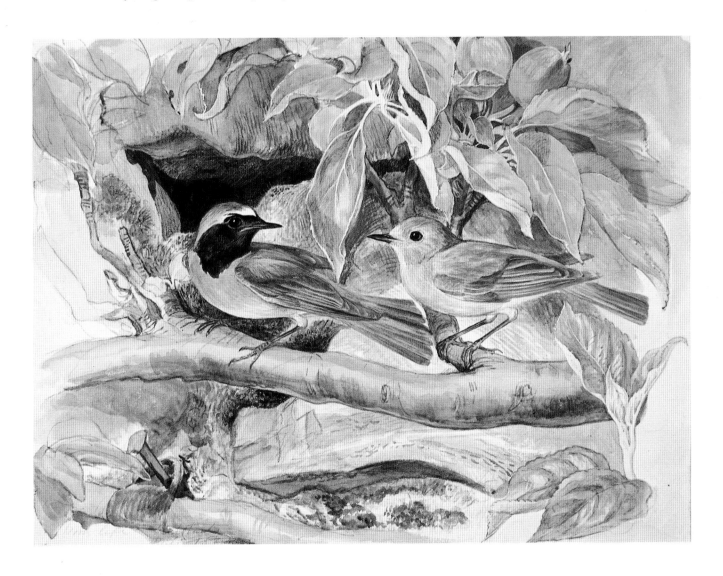

THE Stonechat [*left*] is less common in this part of the West Highlands than either the Whinchat or the Wheatear, but seems to remain all the year – at least we have seen it in late autumn. In voice and manner it resembles the Whinchat. It makes its nest in low bushes. The male is bright and conspicuous and generally perches on the top of a bush. (Illustration from the coloured version of *Birds from Nature*)

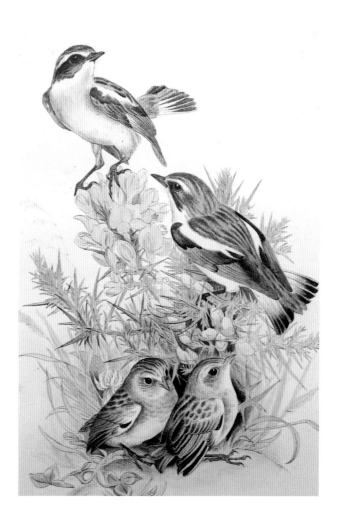

❧ WHINCHAT ❧

THE young Whinchats in the picture [*right*] are from life; the old birds (male above, female below) are from fresh specimens. Whinchats are common at Roshven among the whin (furze) which thrives particularly well in some parts of the low ground near the sea. They are lively, and make a clicking sound, such as is used to make a pony go on.

THE Wheatear [*left*] is common here as a summer visitant, inhabiting the open ground, and making its nest on the ground or in turf banks. The female is duller in colour than the male, and without so dark a mark at the eye.

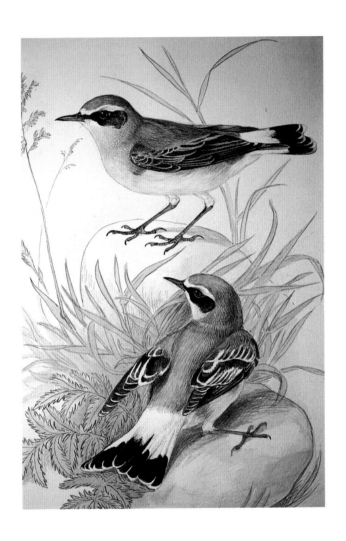
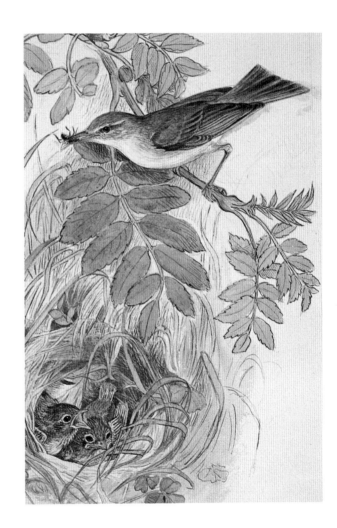

⊁ WILLOW WARBLER ⊁

The nest of the Willow Warbler [*right*] is from nature, and the birds, young and old, from life. The old bird was caught by putting the young ones in a cage. The whole were [*sic*] replaced when the drawing had been made; after which the young were reared by their parents as if nothing had happened. The bird is common in Moidart. Its singing is soft and sweet.

THE illustration is a sketch done from life in the Zoological Gardens, London, some years ago. It was easier to get near it there than when flying about the hedges in England, although once, near Canterbury, I did get close enough to observe how it swelled out its throat when singing.

It is not completely unheard of in Scotland. Lady Margaret Cameron of Locheil has kindly sent me the following:

> *A Nightingale was heard for three weeks, and also seen, during the month of June 1889. Thermometer 90 in the shade in May. Very hot all May, June, and July, but cold and wet in the south and east of England.*

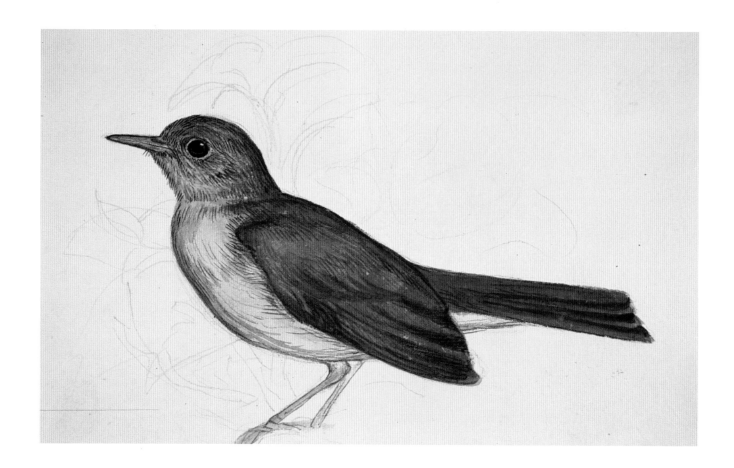

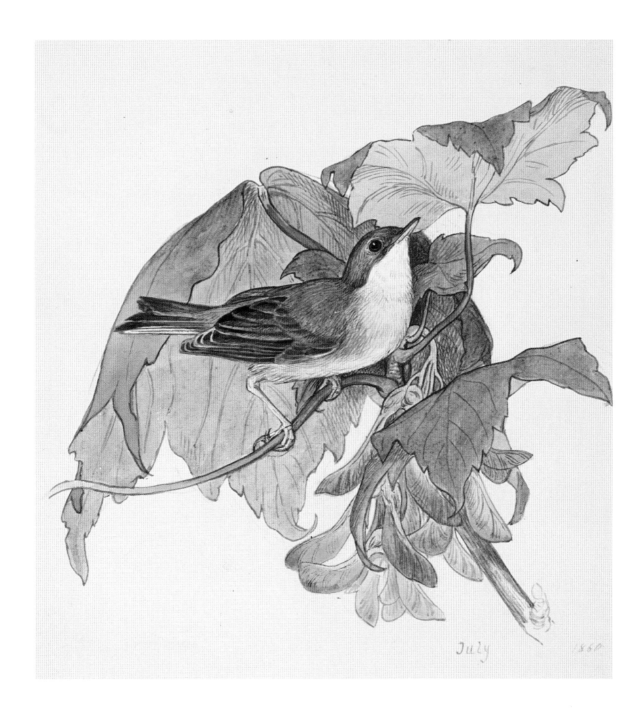

THE Whitethroat is common here in summer, but not very numerous. It keeps very much out of sight, in 'leafy labyrinths', hunting for insects among the bushes and under the leaves. Unlike many of the soft billed, insect-eating summer visitors, its notes are rather harsh.

THESE were done from live birds, caught in winter, and kept in a cage for a few days to have their attitudes studied and their portraits taken, when they were let go again. It is active and various in its attitudes; has a yellow breast and blue bonnet, and is altogether a very attractive little bird. Besides the Long Tailed and Blue Tit we have also observed in Moidart the Great Tit, or Ox-eye and the Cole [*sic*] Tit.

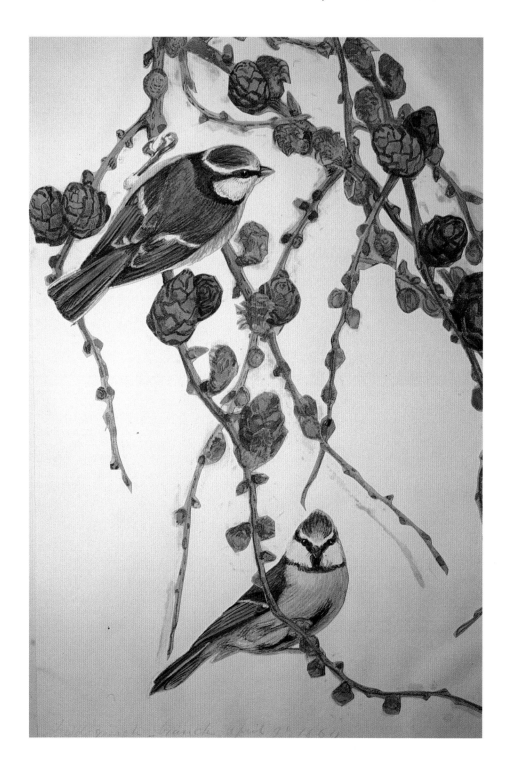

THE birds illustrated were obtained in Kinloch Moidart [*sic*], where they had bred. They had pink eyelids, a point which Yarrell does not mention, but in other respects agreed with his description. They are cheerful, loquacious little birds and may be seen in large family parties in summer, among the twigs of the birches. They are easily recognised by their long tapering tails.

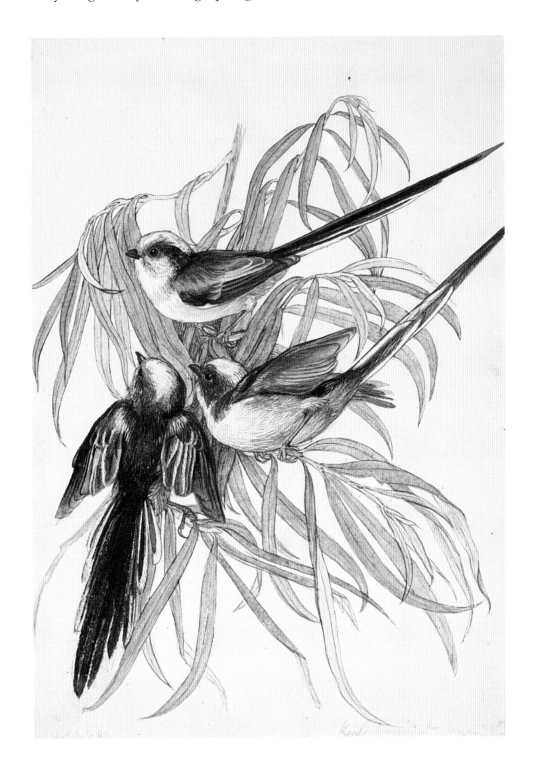

A few pairs of this pretty bird are to be found in Moidart,

> *By the rushy fringed bank,*
> *Where grow the willow and the osier dank.*

The female differs from the male in having the head brown instead of black. I have seen the male flying among the saugh bushes with a caterpillar in its beak, evidently going to feed its young but I did not find the nest. I have never seen it in winter, nor near a house. It is sometimes called the Reed Bunting from its habit of frequenting marshy places.

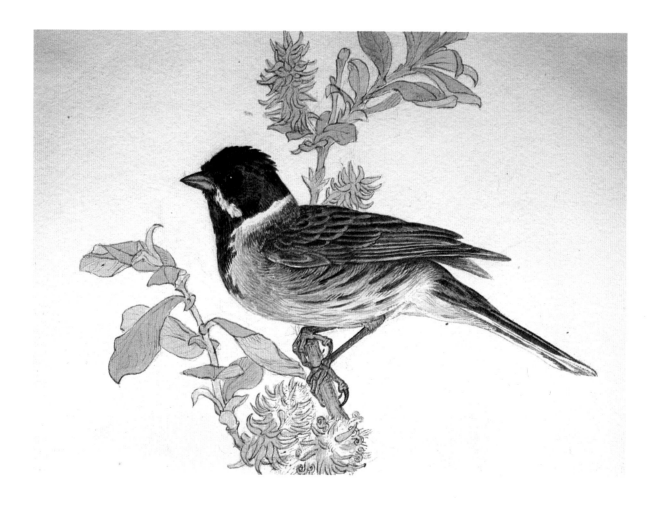

THE Yellow Hammer's nest among the uncurling ferns and the dog violets is from nature at Roshven. The bird remained on its eggs while the drawing was being done. Yellow Hammers used to be very common before the Sparrow invaded us. (Illustration from the coloured version of *Birds from Nature*)

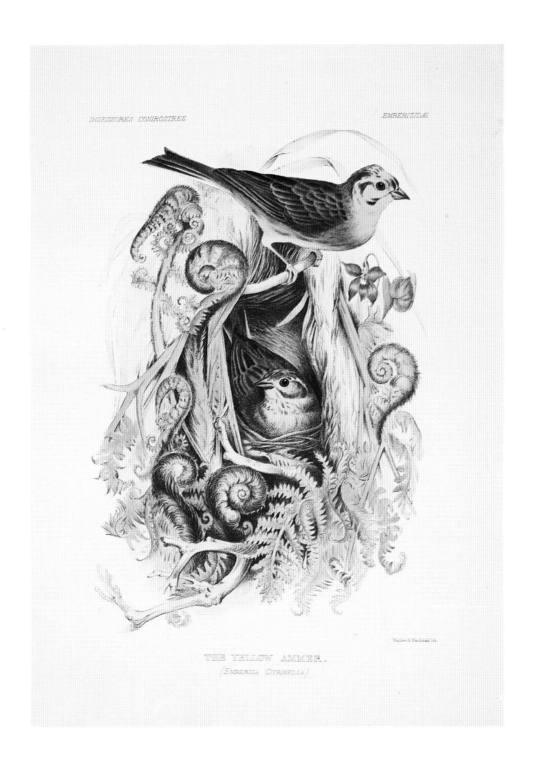

INCESSORES CONIROSTRES EMBERIZIDÆ

THE YELLOW AMMER.
(*EMBERIZA CITRINELLA*)

BULLFINCHES [*left*] are common here, and do a good deal of damage in the garden, coming in flocks and eating the buds off the fruit trees and gooseberry bushes. They look very pretty when picking among apple blossom. In general they inhabit the birchwoods summer and winter, and their soft voices may be heard at all seasons, 'sole or responsive each to other's note'. They have rather a poor song of their own, but can be taught to whistle tunes very sweetly in confinement. They are very nice cage-birds, easily tamed, even when caught old; very affectionate to those they love, and sometimes showing a marked dislike to strangers. They are not generally long-lived in captivity, being very apt to die of apoplexy.

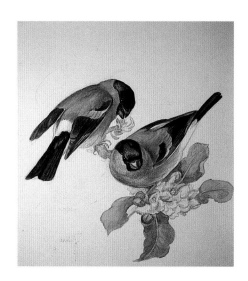
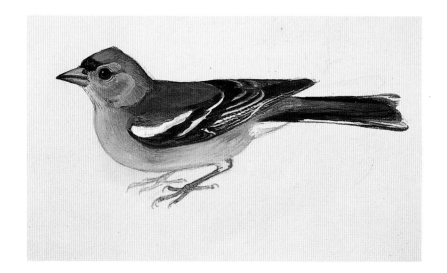

⤨ CHAFFINCH ⤪

THE Chaffinch [*right*] exists here in great numbers, most obviously in the winter time, when great flocks of them frequent the bare fields, picking up what seeds they can find (of weeds, probably, as it is long after the corn has been carried). To judge by the plumage they were hen birds, but some of them may have been young males, who do not acquire their bright feathers till spring. The Chaffinch is not musical. He seems in his song to proclaim himself 'a little, wee, wee, drunken sowie.'

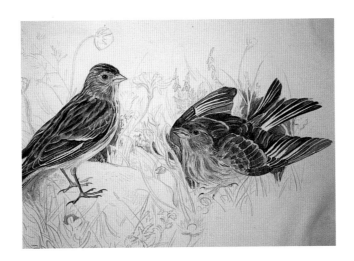

⌁ TWITE, LINNET & REDPOLL ⌁

THE common Linnet is to be seen here, the Twite [*above*] still oftener [*sic*], and the Redpoll most of all. It builds on the apple trees in the garden a neat little nest, but not quite equal to the Chaffinch, who also builds in the apple trees at the time the tree is in blossom, its grey lichen-covered nest contrasting beautifully with the pink flowers.

Linnets (of sorts) are more or less tinted with rose colour. The Common Linnet has it on the breast, the Twite on the rump, the Redpoll [*below*] on the breast, and also a brighter crimson on the forehead.

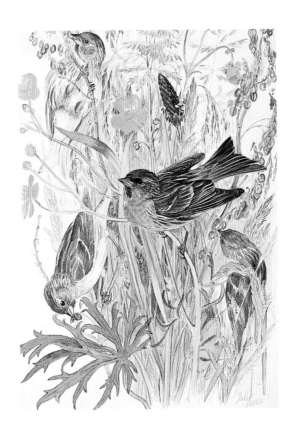

THE Crossbill is to be found in the North of Scotland. These birds were obtained in winter at Ruthven, in Forfarshire. The three birds were killed at one shot while climbing about in various attitudes in a larch tree. They varied considerably in col-our, some being much tinged with red, some with green. The beaks are very peculiar, and seem to answer their purpose admirably in enabling the bird to extract the seeds from fir cones. (Illustration from the coloured version of *Birds from Nature*)

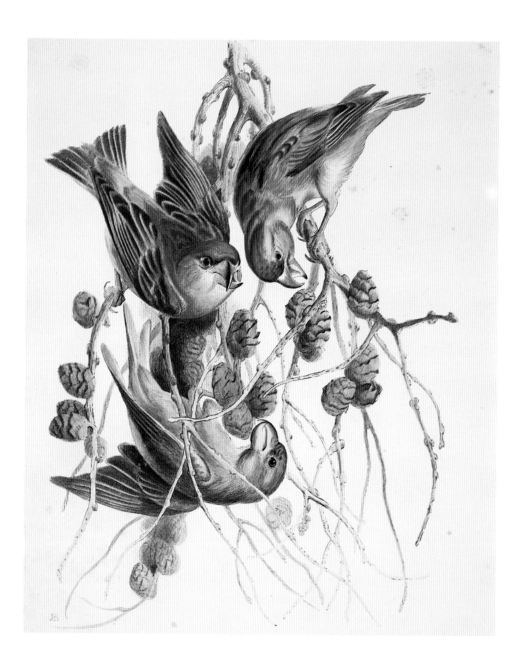

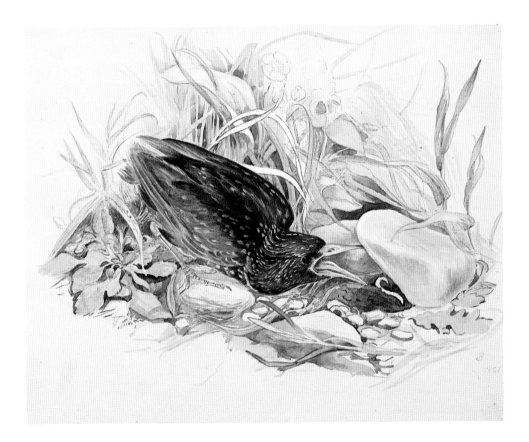

THE illustration was done from a tame Starling I had, which, when let out of its cage to run about on gravel, would put its beak under the larger stones, and, by opening it wide, raise them and look if there were any worms or insects beneath. It came on board the steamer *Palestine*, in a storm, in the Bay of Biscay, when I was on my way to Egypt, and was caught and given to me by one of the sailors. It soon became quite tame, and would eat out of my hand, and much enjoyed being washed and gently dried with a pocket-handkerchief. I took it with me to Egypt and then home again to Scotland.

To my great grief it died within the year of atrophy during its moult. Its health had, I think, been injured by the over fatigue of a long railway journey through France and England. Railway travelling does not seem to suit birds. The continuous clinging to the perch night and day so as not to be shaken off it fatigues them greatly. They stand the swinging about in a sea voyage much better, even when it is rough. There were no Starlings when we first came here in 1856. Many rested on the islands when migrating, as many of them do. In Canna I have seen a little tree quite covered with them. They began to come here a few years ago, and now a good many stay all the year round, and live in the dovecot with the pigeons.

Starlings seem to me to be much more numerous in Scotland than I remember them long ago, both in town and country. There are many in the old parts of Glasgow, and as soon as the New University Buildings were finished they began to inhabit them.

THIS bird, sometimes called the Greybacked Crow, visits the Eastern counties of England annually in autumn and winter. It is called there the 'Royston Crow', and in Scotland the 'Hoodie'. It remains here at all seasons. Like the Vulture it has a liking for carrion, or rather an eye for a sick-fallen beast; and though none may be in sight when a sheep falls or dies on the hill, they will soon assemble around the carcase and begin their feast, even sometimes before the poor animal has breathed its last. They are the plague of shepherds and gamekeepers, being very destructive of game and eggs, as well as young and feeble lambs.

The young Hoodie here drawn was so good as to fall uninjured out of its nest on an old aspen tree growing out of a rock on the island at the mouth of Loch Ailort, the day we went to try and get at it.

✤ RAVEN ✤

THE Raven is not an every-day sight here, but seldom any very long time passes without one's seeing and hearing two or three of them flying high overhead and uttering their well known croak. They are very wary and unapproachable, more so than even the Carrion Crows. Unlike them it does not frequent the seashore in search of food. I have several times kept tame Ravens, which make most amusing, but rather inconvenient, pets – very affectionate to their owners, but mischievous in the extreme, and malevolent towards strangers. My first, a very fine large bird, had the name of 'Beelzebub', which many of my friends thought it deserved. The nest from which it was taken was near Loch Ard, on a high rock, called by a poet in that neighbourhood, 'the crag of Grahame's destiny'. It was very wild at first, but by keeping it beside me it soon got quite tame, and would sit on my shoulder without ever offering to bite. When a visitor called, it always made a point of ascertaining whether he wore

boots or shoes, and applied his beak accordingly, and was especially severe on thinly-shod ladies. When I had kept him in my room one day to draw his portrait, he collected my slippers and put them in a basin of water which I had set for him to drink or wash in. When corrected for his misdoings, he would lie down and croak penitentially, and as soon as forgiven would repeat the offence. Woe to any hedgehog, toad, or other small animal he might meet when out if they were not rescued at once. Even the flowers did not escape his destructive beak. One day when we shut him in the garden, not wishing him to follow us, we found on our return all the gay tulips that had that morning adorned the borders gathered and laid out in rows on the walk. When in town he could not do so much harm, but danced about on the back green, cursing and swearing like an angry Frenchman, pinching the tails of the dogs and cats that were rash enough to go within his reach. He cared most for a large bull dog with a very short tail, and nose to match, not so easily laid hold of as the better developed extremities of the lesser ones, and of whom he stood in some degree of awe; but even he was made sometimes to feel the power of 'Beelzy's' beak. Though its gibberish sounded like human language (not of the best), I never heard it say any words that could be recognised. There was no attempt made to teach it to speak. It existed before the time of *Barnaby Rudge*.

My second pet Raven I got from a nest in this neighbourhood. It was not so fine a bird as 'Beelzy', but had the same love of mischief and sense of humour. During our absence one winter, a friend, fond of animals of all sorts, offered to take care of 'Asmodeus' for us, for which good nature her chickens suffered. He was allowed the use of his wings. One day he stole the priest's prayer book, and flew off with it to the top of the house, where the impious bird, with sacrilegious beak, tore it leaf from leaf, scattering the sacred pages to the winds, while Father D—— stood below in helpless despair; but all the time, with true Catholic charity, excusing it on the plea of 'invincible ignorance'. 'Poor thing it does not know what sin it is committing.'

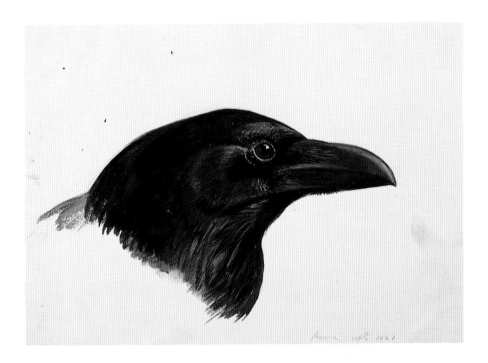

❧ MAGPIE ❧

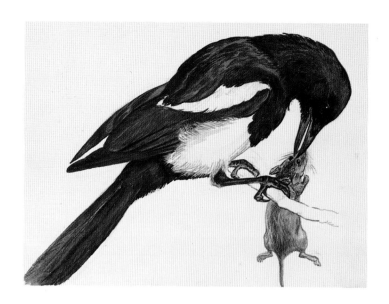

❧ LESSER SPOTTED WOODPECKER ❧

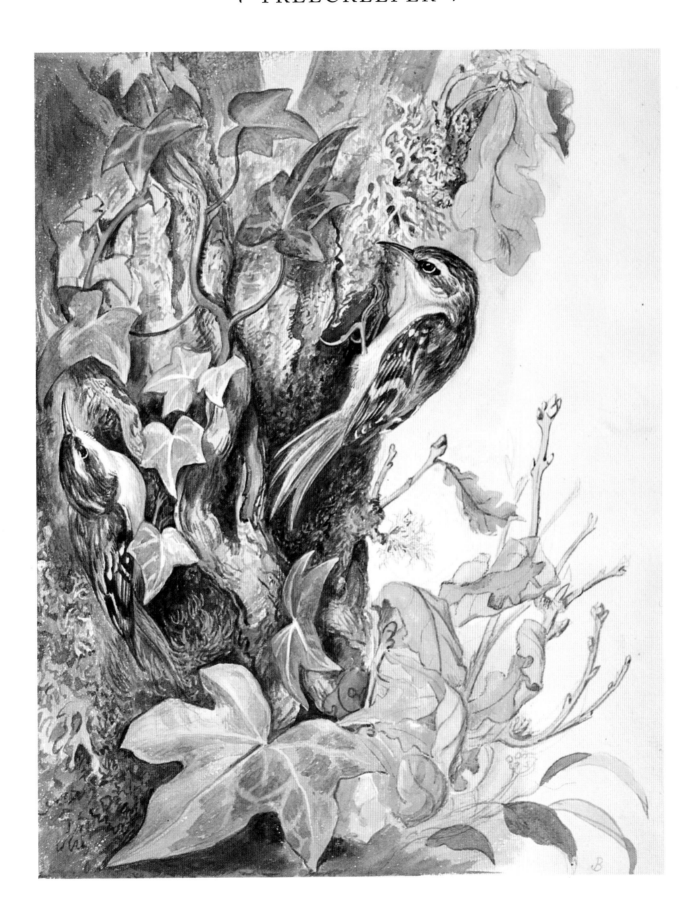

✻ WREN ✻

VERY common here – more so, perhaps, among the rocks and heather than even about the garden. Its song may be heard in winter as well as in summer; it is more loud than melodious, somewhat like that of a second-rate canary. I have observed, when I have had occasion to sit up all night in cases of illness, that its song was the first to be heard at very early dawn on the summer mornings. I heard a wren singing on the 3rd of January 1895, in the garden of a cottage where I had been visiting. It was late afternoon – 'the sun was set, but yet it was not night'. There was a beautiful afterglow lighting up the snowy landscape and tingeing [*sic*] the hills with orange. No wonder it was moved to chant a benedicite.

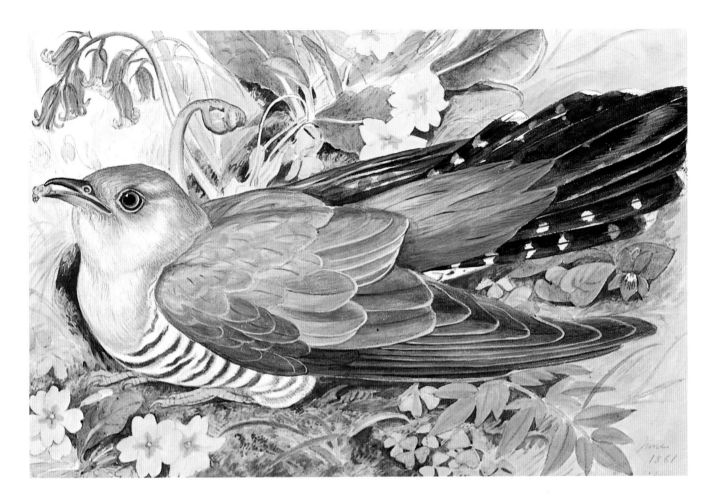

THE next plate is drawn from a bird which was caught alive and kept for a few days. There are usually a good many Cuckoos in our neighbourhood, and they are to be seen constantly during the season on the open ground, as well as among the trees and brushwood. The attitude represented is not uncommon when the bird settles on the ground in search of insects.

The adult Cuckoo is slate grey above, the breast white, barred with black, eyes pale. In its first plumage the young Cuckoo is red brown, with dark bars on the upper parts, and white barred with black beneath, and eyes dark hazel. It greatly resembles a Kestrel Hawk; it is called the Red Cuckoo, and has probably been at some time mistaken for a different species, as young Sea Gulls have been. When I met Mr Harting of the Linnean Society in London this Spring (1895), he told me he had just had sent for his inspection, on its way to the bird-stuffer's, a young Cuckoo in its first plumage, recently shot by a gamekeeper, who had mistaken it for a female Kestrel. In the July 1895 edition of the *Zoologist* he wrote: 'On dissection this bird proved to be a female, but with no marked development of the ovaries. This peculiar phase of plumage in the Cuckoo has been long known and described by several Continental writers, but is of such infrequent occurrence in England as to deserve some notice when met with'.

I have heard of a Cuckoo having been shot with an egg in its mouth, which has probably given rise to the belief prevalent in the South of Scotland that Cuckoos eat other birds' eggs. There is an old nursery rhyme to that effect:

The Cuckoo is a bonny bird, she sings as she flies;
She brings us good tidings, and tells us no lies;
She sucks little birds' eggs to make her voice clear;
And always sings 'Cuckoo' when spring-time is near.

The old English rhyme makes the Cuckoo masculine, is less imaginative and more in accordance with known facts:

In April, come he will;
In May, he sings all day;
In June, he alters his tune;
In July, he prepares to fly;
Come August, go he must.

When we found a Cuckoo's egg it was in a nest limited in size, from being built in a bank which shut it in on three sides. It was too small for a Cuckoo to sit in so as to lay her egg as birds usually do; so I am inclined to agree with those who believe that she lays it on the ground first, then carries it in her beak to the nest.

It seems Cuckoos' eggs vary very much in colour, maybe in order to match those they are placed among, so that the foster-mother bird may be less likely to detect the fraud. I have seen a collection of Cuckoos' eggs in the Natural History Museum in London – some green, or blue, some plain white, as well as speckled brown, like the Pipit's in whose nest my daughter Margaret found one.

Margaret finding Cuckoo's eggs in a Pipit's nest

The circumstances under which the accompanying sketch of the young Cuckoo in the Pipit's nest was made are detailed in the two following letters, which appeared in *Nature*, 14th March 1872, and in *The Lancet*, 2nd July 1892.

Several well-known naturalists who have seen my sketch from life of the young Cuckoo ejecting the young Pipit … Have expressed a wish that the details of my observations of the scene should be published. I therefore send you the facts, though the sketch itself seems to me to be the only important addition I have made to the admirably accurate description given by Dr Jenner in his letter to John Hunter, in the Philosophical Transactions *for 1788 (vol.* LXXVII, *pp.225–6), and which I have read with pleasure since putting down my own notes.*

The nest which we watched last June, after finding the Cuckoo's egg in it, was that of the Common Meadow Pipit (Titlark, Mosscheeper), and had two Pipit's eggs besides that of the Cuckoo. It was below a heather bush, on the declivity of a low abrupt bank on a Highland hillside in Moidart.

At one visit the Pipits were found to be hatched, but not the Cuckoo. At the next visit, which was after an interval of forty-eight hours, we found the young Cuckoo alone in the nest, and both the young Pipits lying down the bank, about ten inches from the margin of the nest, but quite lively after being warmed in the hand. They were replaced in the nest beside the Cuckoo, which struggled about till it got its back under one of them, when it climbed backwards directly up the open side of the nest, and hitched the Pipit from its back on to the edge. It then stood quite upright on its legs, which were straddled wide apart, with the claws firmly fixed half way down the inside of the nest among the interlacing fibres of which the nest was woven, and stretching its wings apart and backwards, it elbowed the Pipit fairly over the

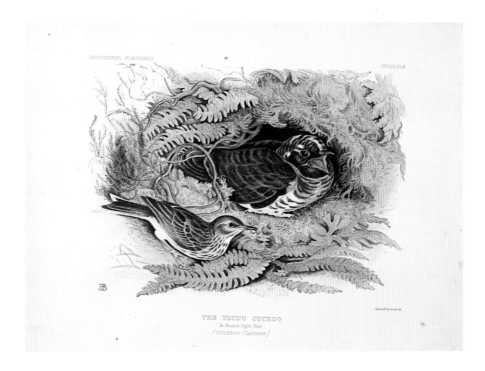

Pipit and fledgling from coloured version of *Birds from Nature*

margin so far that its struggles took it down the bank instead of back into the nest.

After this the Cuckoo stood for a minute or two, feeling back with its wings, as if to make sure that the Pipit was fairly overboard, and then subsided to the bottom of the nest.

As it was getting late, and the Cuckoo did not immediately set to work on the other nestling, I replaced the ejected one and went home. On returning next day, both nestlings were found, dead and cold, out of the nest. I replaced one of them, but the Cuckoo made no effort to get under and eject it, but settled itself on top of it. All this, I find, accords accurately with Jenner's description of what he saw. But what struck me most was this: the Cuckoo was perfectly naked, without a vestige of a feather or even a hint of future feathers; its eyes were not yet opened, and its neck seemed too weak to support the weight of its head. The Pipits had well developed quills on the wings and back, and had bright eyes, partially; yet they seemed quite helpless under the manipulations of the Cuckoo, which looked a much less well developed creature. The Cuckoo's legs however, seemed very muscular, and it appeared to feel about with its wings, which were absolutely featherless, as with hands, the 'spurious wing' (unusually large in proportion) looking like a spread-out thumb. The most singular thing of all was the direct purpose with which the blind little monster made for the open side of the nest, the only part where it could throw its burthen down the bank. I think all the spectators felt the sort of horror and awe at the apparent inadequacy of the creature's intelligence to its acts that one might have felt at seeing a toothless hag raise a ghost by an incantation. It was horribly 'uncanny' and 'gruesome'.

J. B., *The University, Glasgow*

Sirs, — *The confirmation of Jenner's observations as a naturalist, which formed the subject of your leading article last week, is the latest, but it is not the one that is best known. Another confirmation made in 1871 was published in* Nature *(vol. v, p.382), which is even more interesting as bearing out Jenner's original account in its most distinctive and most minute points, and as having served to convince Darwin, who introduced a paragraph into his latest revision of the 'Origin of Species,' calling it 'a trustworthy account of a young Cuckoo, which was actually seen, whilst still blind and not able even to hold up its own head, in the act of ejecting its foster-brothers.' To show how closely Mrs Blackburn's account agrees with that of Jenner, I have written a few sentences from each in parallel columns. The original observations were made near Berkley on June 18th, 1871. In the former case a Hedge Sparrow's nest contained when first seen two of the bird's own eggs with one Cuckoo's egg, and next day the newly hatched Cuckoo and one newly hatched Hedge Sparrow; in the latter case a Meadow Pipit's nest when first seen had two partly fledged Pipits with one Cuckoo's egg, and next day the newly hatched Cuckoo only, the two young Pipits, which were several days old and open-eyed, having been found lying on the bank at a distance of ten inches from the nest. They were put back, being still alive, and then ensued the events which are related in the right-hand column:*

Phil. Trans. 1788 p.225

The mode of accomplishing this was curious: the little animal, with the assistance of its rump and wings, contrived to get the bird upon its back, and making a lodgement for the burden by elevating its elbows, clambered backward with it up the side of the nest till it reached the top where, resting for a moment, it threw off its load with a jerk, quite disengaged it from the nest.

It remained in this situation a short time, feeling about with the extremities of its wing, as if to be convinced whether the business were properly executed, and then dropped into the nest again.

Nature, vol. v, p.382

The newly hatched Cuckoo struggled about till it got its back under one of them, when it climbed backwards directly up the open side of the nest, and pitched the Pipit from its back on to the edge. It then stood quite upright on its legs, which were straddled wide apart, with the claws firmly fixed half-way down the inside of the nest … and, stretching its wings apart and back-wards, it elbowed the Pipit fairly over the margin.

After this the Cuckoo stood a minute or two, feeling back with its wings as if to make sure that the Pipit was fairly overboard, and then subsided into the bottom of the nest.'

Dr Norman Moore, in his Life of Jenner in the Dictionary of National Biography, *has called attention to the fact that the well known naturalist Waterton, had rejected Jenner's narrative as incredible. 'The young Cuckoo', wrote Waterton, 'cannot by any means support its own weight during the first day of its existence. Of course, then, it is utterly incapable of clambering rump foremost up the steep side of a Hedge Sparrow's nest, with the additional weight of a young Hedge Sparrow on its back. The account carries its own condemnation, no matter by whom related or by whom received'. It is singular that Waterton, who was well known to be a strict Roman Catholic, should have actually used Hume's famous argument on miracles in order to discredit a fact in natural history which was generally accepted by naturalists at the time of his writing (1836). I enclose my card, and I am, Sirs, your obedient servant,*
 M. N. O., June 27th, 1892.

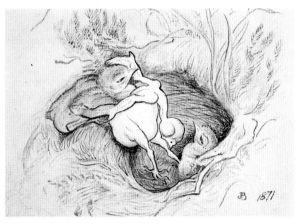

The Cuckoo chick ejecting the young Pipit from the nest

THE Nightjar is a usual summer visitor here. I have seen them often in the gloaming running about on their short legs on the gravel near the house, catching white ghost-moths near the grass. The noise they make is peculiar, something like the purring of a spinning wheel. One cannot tell exactly where it comes from; it seems to pervade space 'above, about, or underneath.' In a modern popular novel they are described as making a clapping sound by striking their wings together. I should think it was more likely they made the sound with their beaks, as their wing feathers are soft and their flight is noiseless, like that of the Owl. A friend who has ample opportunity of observing them, tells me he has heard them make a loud snapping noise with their beaks when they happened to miss catching a moth they were in pursuit of. Their mode of perching is peculiar, sitting on a branch *lengthways*, not across it, as other birds do. So long as they do not move, they are very invisible even in good daylight, their mottled plumage is so much the same colour as the bark of the branch they sit on. The illustration was done from a freshly-killed specimen shot in this neighbourhood.

The Nightjar is looked upon as a bird of evil omen in this country-side. During the visitation of typhoid fever here, if one were seen flitting to and fro near the window of a sick-chamber, it was supposed to foretell the approaching death of the inmate.

Can it be this bird that Shakespeare in *Henry VI* calls the 'night crow' in the description of the birth of Richard III: 'The night crow cried aboding luckless time'.

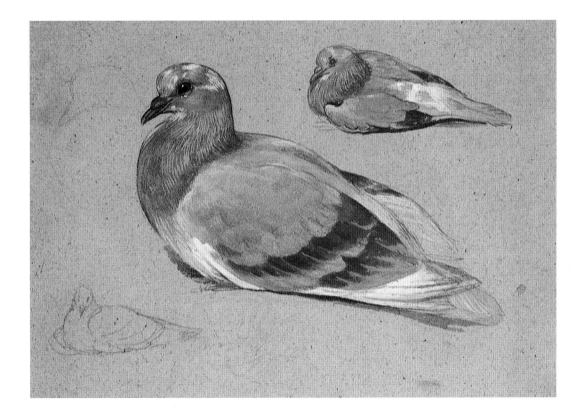

CUSHATS [*Scots for pigeons*] are very numerous in London, and seem to be rather on the increase. I saw the first pair that came to Whitehall Gardens, nesting in one of the tall elms, some years ago. There are many more there now. It is not likely that such a shy bird should have come into London from the country, but more probable that London has extended and enclosed them in their old haunts, and that they have spread from one garden to another. It is very pleasant to hear them cooing among the trees in town on an early summer Sunday morning when all is still, and one is not disturbed there by the thought that they are picking the hearts out out of the young cabbage plants in one's garden, or spoiling the turnips in the field. I have never seen them in Edinburgh or Glasgow, but there used to be many in the Tuilleries Gardens in Paris before the siege. They used to come for crumbs when the children were feeding sparrows there. I believe there are none now. In the South of Scotland they are very numerous. I have heard a tradition there that they used in old times to build their nests on the ground; but, their young having been so often destroyed by passing cattle, they took to nesting in trees. From that safe altitude they now shout to their former enemies in triumphant defiance, 'Coo, coo, coo! Come noo, come noo!' We have very few here in Moidart.

Although they are very strong, hardy birds in general, I have known them to be destroyed by a disease that prevailed among them a good many years ago in Kirkcudbrightshire, where I have found many of them lying dead in the woods, with swelled throats, and quantities of matter oozing out of their mouths and eyes.

The Rock Dove can be found in Moidart. I have seen a nest in the ruins of Castle Tirrim, the former abode of Clanranald. They are very numerous in the caves in the West Highland rocky coast, especially the 'Cathedral Cave' in the island of Eigg (so called because the Catholic natives used to meet there for mass when their religion was proscribed elsewhere. They now have a chapel, and resident priest on the other side of the island, and the 'Cathedral' is occupied by Rock Pigeons, who build their nests on the high shelves of rock inside it, flying out with a noisy clatter when disturbed by visitors). The rock greatly resembles its descendants of the Dovecot, with characteristic black stripes on its wings, which are said to recur when fancy breeds get mixed. They never perch on trees. I have never known the Dovecot Pigeon build on trees, though I have daily seen them perch there while waiting to be fed. The pale blue ones look lovely on an old apple tree among the pink blossoms. I never knew them roost for the night on a tree. The domestic pigeon is a very hardy bird, minding neither cold nor heat, and positively enjoying rain. I have seen them lying on their sides on the wet grass, holding up a wing the better to let the rain get in among their feathers, and sometimes getting so thoroughly soaked by this natural shower bath as to be hardly able to fly after it. All they care for is a shelter from the wind. This so called 'Bird of Venus' is proverbial for its amorous disposition; so much so , that I have known one set his affections on an old croquet ball for want of a more worthy object, and follow it about, strutting round it with spread tail and proud gesticulations, and cooing soft endearments to the insensate block.

In the West Highlands the natives have a sentimental dislike to killing or eating pigeons and according to Yarrell a similar feeling is said to prevail in Russia. In Egypt however, they are a favourite food, provided they are killed by bleeding, accompanied by prayers in the orthodox Mohammedan fashion. We were invited to dinner at the house of the captain of our dahabieh, where the banquet consisted chiefly of roast pigeons, served on a tray on the ground, and we sat round as we best could.

Pigeons do not drink, like other birds, by sipping the water, and raising their heads to swallow it; they plunge their beaks well down into the water, and imbibe it in great gulps like a thirsty horse. At the village of Girgeh, on the Nile, they have an exceptional way of drinking. They fly to the middle of the river, and flutter over the water, dipping their beaks in it as if they were sea birds. I do not know of their doing so anywhere else. Pigeons are abundant drinkers, as well as voracious eaters.

Illustration painted at the age of fourteen

WE do not see many Grouse on the hills above Roshven, although the ground is suitable, nor are those that do exist of so rich a colour as those of the Perthshire moors. It was many years before I could do a drawing of them from life. The young were drawn some years ago having been caught squatting among the heather. At an early age they resemble young black game, except that the toes are feathered all the way down to the claws, and the hind claw is much shorter, as they are not perching birds. I never saw one perch on a tree. They feed almost entirely on heather, but will eat wild oats when they can find a field of them near the moor.

The cock Grouse takes great care of the brood, and assists the hen to defend them. In late autumn, when the coveys unite and fly about together in a flock and get very wild, instead of being put up by keen-scented dogs, they are driven by beaters to the shelters where the sportsmen are concealed to get a shot at them as they pass. Many such hiding places may be seen on the Aberdeenshire moors.

THE Blackcock is less scarce here than the Red Grouse, or, at least, is more in evidence. Perching as he does on the leafless birch trees in winter, and inhabiting lower and more frequented ground near the coast, which is indented with bays and creeks, he can fly across when pursued, and so elude the sportsman. He is not so cautious in avoiding the wire fences, which often prove fatal when he flies against them. In springtime we have often found them dead from that cause. They feed very largely on the buds of the bog myrtle. I have found their crops quite full of it, emitting a strong aromatic scent when opened. In winter they tend to eat alder catkins.

I captured some young ones once which were hiding in the heather, and kept them in a cage for a few days, feasted them on green pease [*sic*] and let them go again. They are much like young grouse at an early age, but the feet are not feathered down to the end of the toes, as those of Grouse and Ptarmigan are.

The plumage of the hen differs entirely from that of the cock, being a sober mixture of brown and grey-mottled feathers. She takes all the charge of the young, while he struts about among the other members of his harem; for, like the Peacock and Pheasant, the bird is polygamous, as are those gorgeously-attired Eastern potentates.

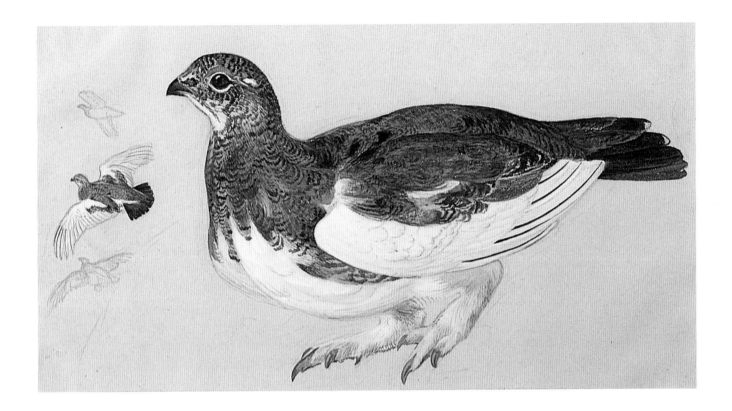

PTARMIGAN are very numerous on the high mountains, abiding at a height of two thousand feet or more above sea level. When pursued Ptarmigan run rather than fly, only taking short flights round the hill top, and alighting when out of sight. I have seen a brood in summer near the top of Ben Lomond being carefully tended by both parents. I was sorry I had not materials to make drawings of them.

Many years ago I saw a beautiful oil painting by J. Wolf (that best of bird painters), of a group of Ptarmigan, with the appropriate background. They are very pretty birds. In summer the plumage is grey on the upper part and white on the lower, the feet well feathered down to the toes, a bright scarlet wattle over the eyes, and black lines down the middle of their white quill feathers. In winter they become nearly all white; of this colour they are mostly to be seen in the poulterers' shops.

WHEN we first came to Roshven in the mid 1850s there was one pair of Partridge in the area, they had an occasional brood, but died out some years ago. We hatched some Partridge eggs in the incubator, and tried to rear them with a foster mother, like chickens, but without success. We then got four pairs of full grown birds. They arrived during frost in winter, so we had to keep them enclosed for a time until the thaw came, and fed them on fresh cabbage and grain. We let them out two at a time, to let them get accustomed to the place, for fear they should fly away together if they were all set at liberty at once. They remained near for some time, coming back for the food laid out for them, and sometimes feeding with the chickens, or joining the Pheasants.

They very soon took to feeding on the seashore, among the cast-up seaweed, and finding 'hoppers' and other marine delicacies, showing rather a remarkable taste for inland bred birds imported to London from Hungary. In due time they nested, and hatched small broods, but they all disappeared in the course of the year, probably having become the prey of Sparrow Hawks or escaped cottage cats, of which we have more than enough! Perhaps the worst destroyer of all is the collie dog, when not under restraint. It does its hunting far from its own home, going off during the night, and returning in time for its duties in the morning, quite unsuspected by its owner, who knows it never kills chickens at its own door, and who will not believe that it has done so elsewhere, and is not easily persuaded to keep his dogs in couples when not at work. I have had as many as eighteen hens killed and buried in one night by a shepherd's dog, which returned some days after to dig them up. Being an excellent animal in other respects, she was pardoned.

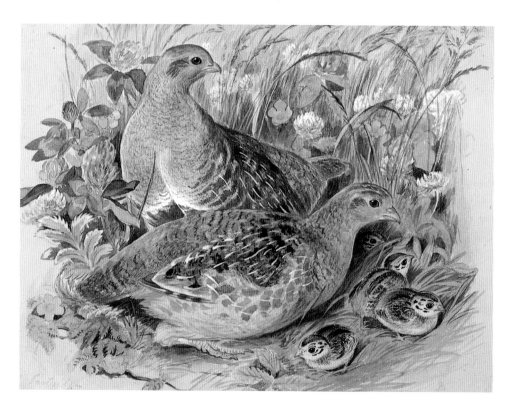

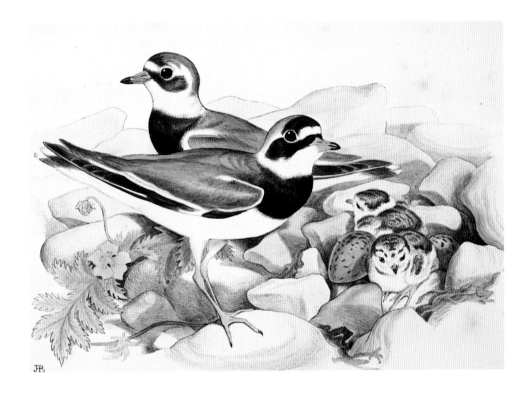

THIS bird is very common here and always to be seen near the shore. It makes no nest, but lays its four eggs in a slight depression of the ground, with the four small ends together, as is the custom of Plovers. They are so very like the colour of the gravelly shore on which they are laid, not far above high water-mark, that they are very difficult to find, so it is as well to take their bearings carefully, or to put some mark whereby you might find them again.

We visited them daily till the first egg was hatched, so as to get both eggs and young in the picture. They go off into the wide world as soon as they are out of the shell, the eggs all hatching within about four and twenty hours of each other, having nothing in the way of a nest to return to. Their habits, in all other respects, are very like those of the Sandpiper, keeping the same stillness in the time of danger when warned to do so by the cries of the parents, who both guard the young and expose themselves to danger by their stratagem to draw off the enemy. (Illustration from coloured version of *Birds from Nature*)

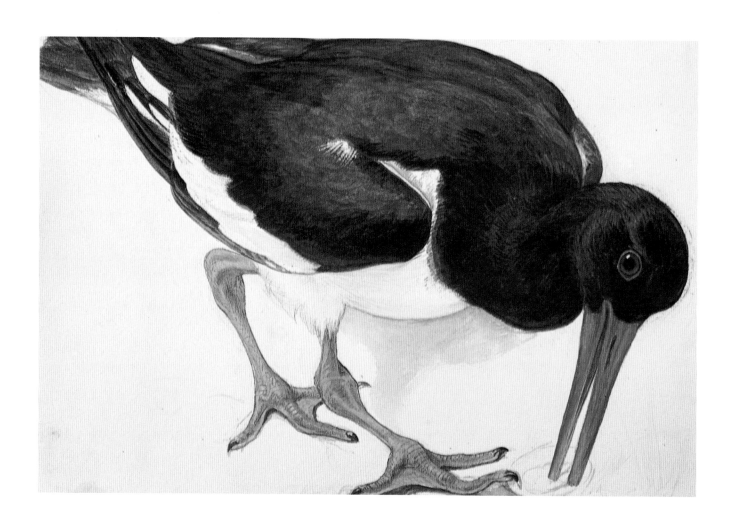

THE Oystercatcher is very conspicious here, with its Magpie plumage, scarlet beak and legs. It frequents the shore in great numbers, seldom silent, and making a shrill outcry on the approach of danger, thereby giving warning to the other shore birds. It builds its nest on the little rocky islands near the sea, and lays four greenish-brown spotted eggs, placed with the small ends together like those of the Ringed Plover. The newly-hatched young are very invisible in their downy state when they lie still in the clefts of the grey lichen-covered rocks, which they greatly resemble in colour. We once caught some young ones fledged and nearly full grown, and kept them in captivity for a while, feeding them on limpets, which they cut out of their shells with their scissor like bills. Oystercatchers wade habitually, but when wounded and hard pressed they will take to the water and try to escape by swimming.

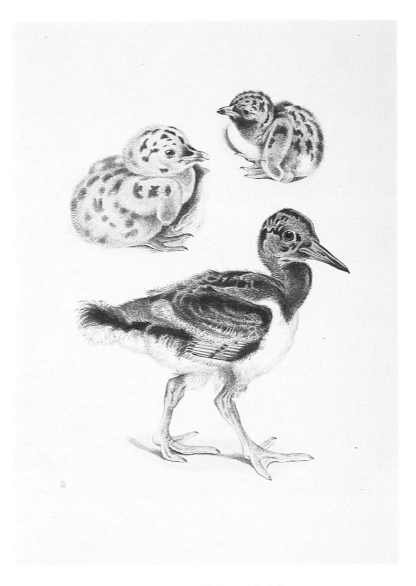

Oystercatcher chicks and fledgling

THE Heron's head was done from a live bird caught at Killearn in a hard frost. It was weak from starvation. We brought it home and fed it on raw meat, and afterwards took it to Glasgow and kept it in a garret for ten days. It ate herrings out of a bath, and then stood on one leg on a chair for an hour or more, quite still, in a favourable position for being drawn. When the thaw came it was sent back by rail to Killearn, and let go where it was found.

Herons build on a little rocky island in a fresh water hill loch about four miles from here, on little stunted birch trees, not far out of reach. A boy fetched down two of them for me; they were fledged, but not yet able to fly. They didn't attempt to peck at him, but made great resistance to leaving their birth-place, holding on to the branches with beak and claws as if they had been parrots. We took them home, but did not clip their wings or confine them in any way; only deposited them on the branch of a laburnum tree, where they looked remarkably well among the yellow blossoms. They soon got very tame. We fed them on fish when we had it, and at other times on raw meat. They would eat bread or porridge, or almost anything, often picking up bits of boiled potatoes with the hens and ducks. They sat for many hours quietly about the back door during the day, or flew down to the seashore for a while; and in the evening, when the days shortened, they would stalk into the kitchen to look at the bright fire and see the lamp lit. They always spent the night out of doors, only taking the sheltered side of an outhouse in a stormy winter night. The next spring they began to carry sticks about among the rocks and heather as if they thought of building a nest, but nothing came of it.

In the course of time one of them died. There was no post-mortem, but it was reported to be very fat. The following spring the remaining one disappeared for some months. It probably went to the island it came from, and may have hatched a brood for aught we know. It returned late in summer, and was found, as usual, as still as a stuffed bird at the back door, near the larder, waiting for its dole and as tame as ever. The spring after, unfortunately, it did not go away off the place, but was accused of waylaying and devouring young ducks about the cottages, and one day came home with a broken leg. Probably a stone had been thrown at it to stop its depredations. So there was no alternative but chloroform. I was sorry to part with it. It was both interesting and ornamental.

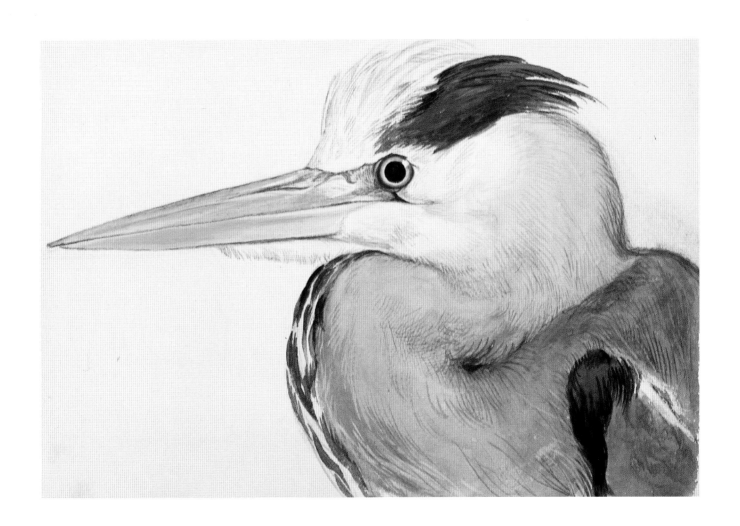

THE Woodcock breeds in Moidart, as well as in other parts of the north of Scotland; but, besides the native, there are many immigrants in winter, especially during frost, when they come to the milder climate of the western sea coast. The nest in the illustration was at the foot of a small rock amongst withered oak leaves which covered the mossy ground, and of which the nest was artlessly constructed, but artfully concealed, as nest, eggs bird, and ground were all of the same colour, so that one may have passed it without notice. The eggs, four in number, were placed Plover fashion with the small ends together. Their great idea of safety is to be as invisible as possible, by remaining perfectly still in the hopes of escaping the observation of the enemy. Young snipes [*sic*] and Sandpipers do so when warned by the outcries of their parents. It is a most convenient habit when one wishes to draw them.

A Woodcock was given me once which was caught unhurt by one of the beaters in a shooting party in Forfarshire. It was hiding itself under a bush. I kept it in a cage for some days, in order to make a drawing of it, and to watch its habits. I put some earth worms in a tumbler with wet mud, and it groped for them with its long sensitive bill, stamping meanwhile with its feet on the floor of the cage, as Blackbirds do when they want the worms to come up out of the earth, but with one foot at a time not both.

When the drawing was done, I took the bird out and let it go, rather to the disgust of the housekeeper, who had counted on it for a roast. It went off stealthily into the wood, and I saw no more of it.

I have seen a Woodcock 'within a mile o' Edinboro' toon' flying about in the gloaming of a winter afternoon.

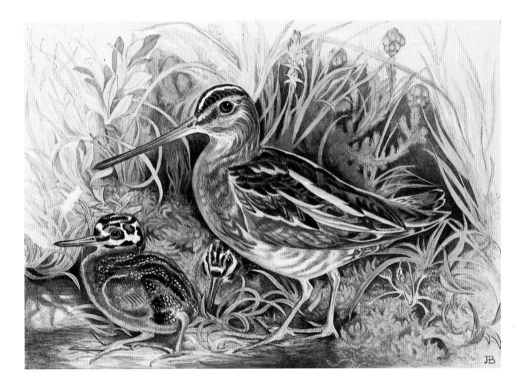

THIS bird is not very numerous here. The Snipe is from a sketch from life, as also were the young; and the ground was from nature, in the place where the young ones were found. When out with a shooter one day in August many years ago, I took him to where I had often seen Snipe, little thinking there would be downy young ones so late in the year. The old birds rose, but fortunately were missed, and the dogs were eagerly smelling about after what we discovered to be two very young Snipe, so I carried one home as quickly as I could, with perfect indifference to wet feet and draggled petticoats, and got it drawn while daylight lasted. The ghillie took it back to the place where it was caught, and found its disconsolate parents still looking for it. It also had the instinct to be still in times of danger. I never had a better sitter; it was as still as if it had been stuffed and put in Kensington Museum.

WE have found Sandpipers' nests in various positions – on the ground, in the side of a bank, or at the foot of a tree, and once only in a low bush, but always near the shore. The young birds are able to leave the nest as soon as hatched, but remain near it for a few days, probably returning to it at night.

The nest sketched was in a bank, and the whole family were drawn from life. The old bird was caught by placing the young ones in an open cage, and shutting the door by means of a string as soon as she went in, which she did immediately on our retiring a dozen yards. There is no perceptible difference of plumage between the male and female, but we presumed this to be the female. They were all restored to their home uninjured.

When the Sandpiper is on eggs, if disturbed she flies away quietly and silently; but if the young are hatched, she flaps about, making a great outcry to warn the little ones to sit perfectly still, so as to attract no attention, while she feigns lameness and impotency to lead away the enemy from the neighbourhood. The young can run very quickly almost as soon as they are out of the egg. They are very small, and so like the colour of the shore, or the banks of the streams they frequent, that it is extremely difficult to see them when they do not move.

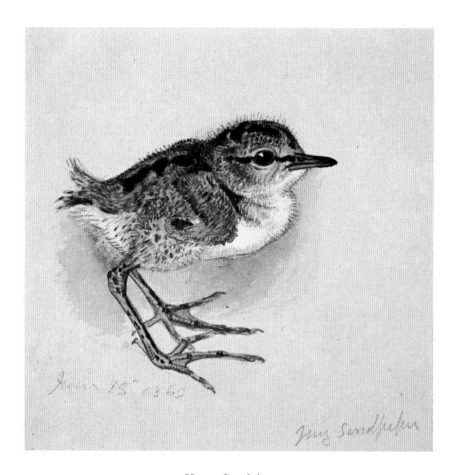

Young Sandpiper

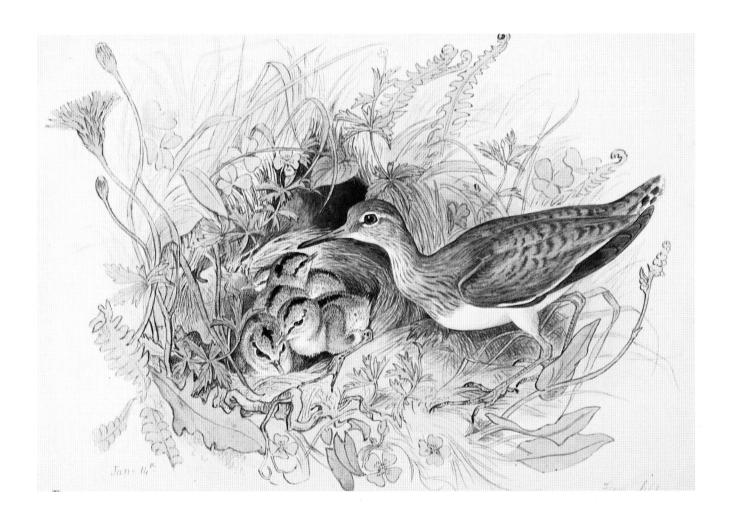

June 14

THE painting of the nest of the Corncrake (or Landrail) was done from nature at Roshven. The nest among long grass, was visited daily, till one egg was hatching. I carried it home, and made a drawing of the little, black, downy young one. When it was half way out of the shell it ate flies out of my hand, picking them up as cleverly as an experienced fly catcher. It seemed to have the power of measuring distance, and taking good aim, as soon as ever it got its head out of the shell. Very few other creatures are so precocious. Chickens are able to pick up food pretty neatly, but they do not begin to eat for the first twenty-four hours of their life. It takes a baby a long time before it can judge distance – even to stretch out its hand to clutch anything – and then it makes a good many bad shots before it puts the thing in its mouth.

After being drawn, the young bird, minus the shell, was returned to the nest. More of them were beginning to hatch, and next day all had left the nest. The attitude of the old bird was taken from a live one I had in the house for a time, and then let go. It went away in a stooping position, threading its way stealthily through the grass, and soon disappeared. While in the house it poked about into all the corners of the room trying to hide itself.

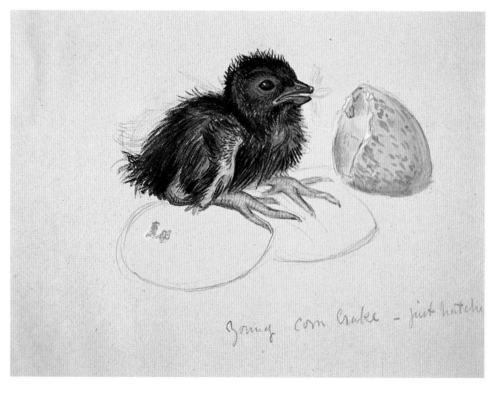

Young Corncrake – just hatched

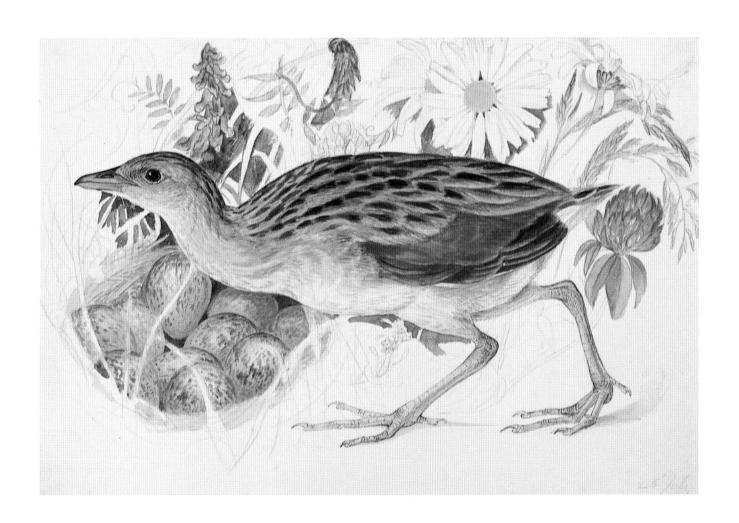

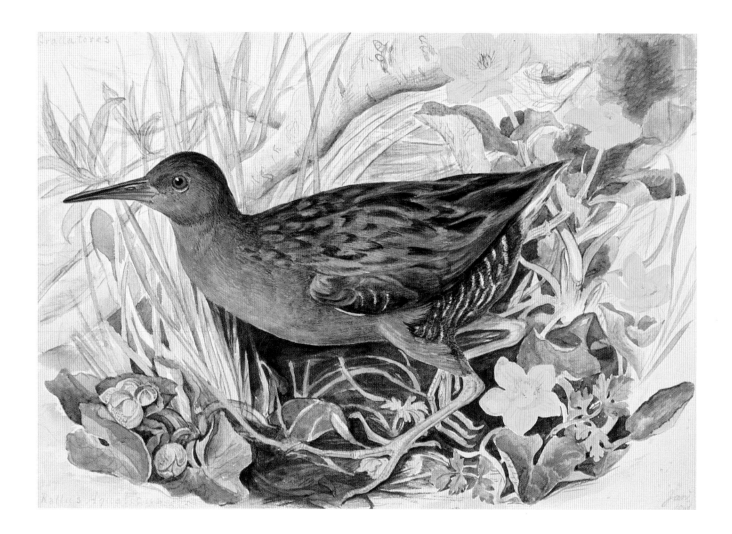

THIS illustration is from a freshly killed specimen obtained in the neighbourhood of Glasgow in 1861. In comparing it with Yarrell's description it was found to differ in the following particulars: The beak, instead of being all red, had the top of its upper mandible nearly black, the rest red, and the irises were vermilion, instead of hazel. There was a light mark on the under eyelid, and some of the wing coverts (the spurious wing) were slate grey, barred with white, like the flanks. In all these points the bird agreed with Pennant's description and plate.

A Waterrail [*sic*] was caught in the garden here this winter, during the long and severe frost, nearly starved. We fed it with oatcake, and it was able to fly away when let go again.

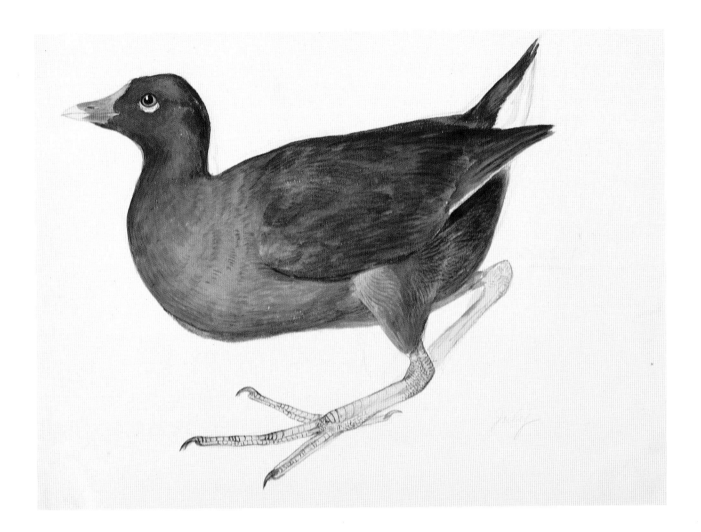

THESE birds are to be found here and in most other places. I hoped to make a drawing of a nest in a horse pond at the foot of a tree beside an old stump, and made a voyage to it in a washing tub for want of other means; but it was deserted. I have seen a nest in a stream on the extremity of a willow branch that stretched out into the water. In spite of all their precautions, Waterhens' eggs are stolen by rats. One has been seen taking them out of the nest and handing them on to its companions to help to get them ashore. Rats are very clever at carrying away eggs out of hen houses without breaking them. A weasel or stoat will break and suck the stolen egg on the spot.

THE head of the wild swan was done from one which was taken alive one very hard winter in a pond at Culzean Castle, in Ayrshire. I had the opportunity of drawing it. It was put in a shed, and was not very wild or much agitated. It lived for seven years afterwards on a small lake where the late Marquis of Ailsa used to keep·a variety of tame water-fowl. I have heard of what I supposed must be Wild Swans being seen one winter in Loch Ailort during severe weather. They were described to me as 'large white birds that made a whooping noise as they flew'. I was not there at the time, and never saw them except in captivity in this country. I have heard of their being seen in Loch Moidart, as well as Wild Geese. They are very commonly to be seen in Iceland in summer. They have not the graceful beauty of the tame Swan, who 'with arched neck between her white wings mantling proudly rows her state with oary feet'. It is much more like an attenuated goose, especially when walking about on land. It is smaller than the tame Swan, and has not the black knob on the base of the bill, nor does it raise its feathers while swimming.

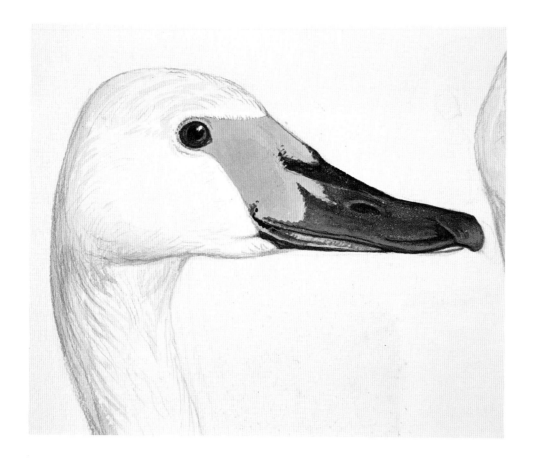

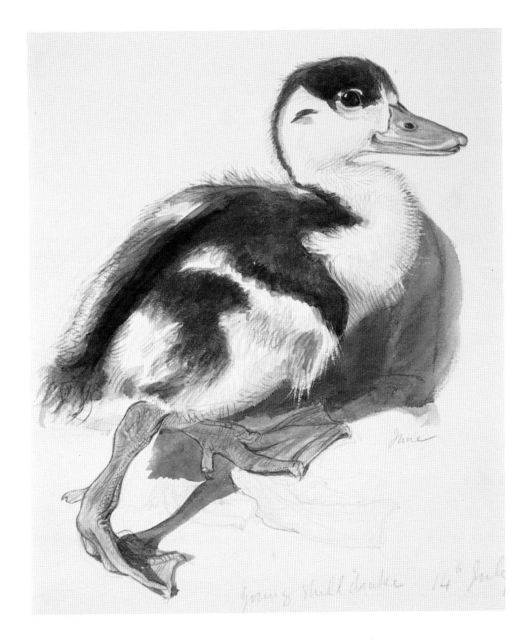

THIS beautiful bird is common here during the summer. I have seen a score of them together flying over Loch Moidart in the springtime. They frequent the shore here, and build in the rocky islands in the open sea at the mouth of Loch Ailort. We got the young one from which the picture is taken on Eilan Treen [*sic*], and we attempted in vane to rear it. My Aunt had a little flock of Sheldrakes, in a pond at Belmac, in Kirkcudbrightshire. They were reared under hens and were quite tame, and used to come to call, to be fed. However they did not remain there long; but when full grown, all of them that were not pinioned flew away back to their native ocean, which was not far off.

The Sheldrake differs from other ducks in that the plumage is alike in both sexes, also, that the male assists in hatching and rearing the young, a work that

other drakes leave entirely to the female, going off to a distance to moult while the duck is in her nest.

The male swan is also exceptional among the anatidae in this respect, helping to rear and defend his offspring. I have seen one pursue a boat, with great fury, that came nearer than it approved of to its incubating mate. The philo-progenitive instinct seems to go along with the similarity of plumage in the sexes. It is strong in the domestic Gander; and among the gallinaceous birds is the same, or nearly so. The Grouse, Ptarmigan, and Partridge are exemplary in their performance of the domestic duties of husband and father, while the Blackcock, Pheasant, and Peacock are notably the reverse.

Some authorities excuse them for this desertion on the plea that their more con-spicuous plumage might betray the nest to their enemies, but I can not think that this is the cause, for, directly after the breeding season, the drake lays aside his nup-tial finery and becomes as dingy as the duck. I can find no answer to this difficult question except the old fashioned one I used to get in my youth, 'It is their nature so to do.'

Unlike the drake (Sheldrake excepted) the Gander in the domestic state takes care of his young. Even when he has two wives, and both have families, he adopts them all, and will, if allowed, take a turn at sitting on the eggs of both his geese. At Killearn it happened that a hen had hatched some goslings, and the Gander killed her because she would not let him have them. When the goose is sitting on eggs, the Gander appears to know on what day they ought to hatch; and, if shut out of the goose-house, will watch at the door for her to come out with her brood.

A Turkey Cock there also took great care of the young Turkeys. He was a great defence for them against Crows and Jackdaws. This was supposed to be an unusual case. With the Gander it is always so. There was an old pet white Leghorn Cock at Arisaig Inn that devoted his latter days to the charge of young chickens, when he was much confined to the house from old age and infirmity. The instinct for nursing seems to occur sometimes in most unexpected quarters. I knew a cat, many years ago, that had a fancy for adopting a young chicken, and sitting in charge of it near the kitchen fire. The first time she did it she had lost her kittens, and may have done so in hopes that the chicken might help to relieve her of her superfluity of milk; but, as she did the same thing another time, she must have been actuated besides by the pure love of nursing. Greater wonders than this have been narrated in old times. In Shakespeare's *Titus Andronicus* we read 'Some say that Ravens foster forlorn chil-dren'. But no such instance has come under my own observation.

WIGEON

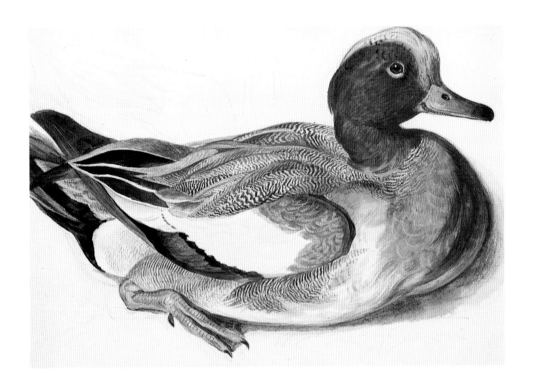

SCAUP

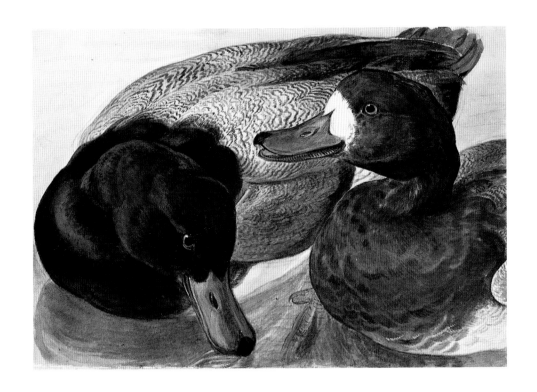

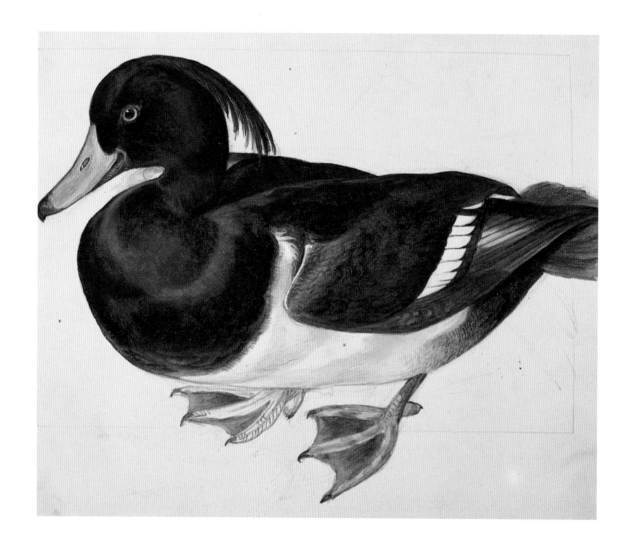

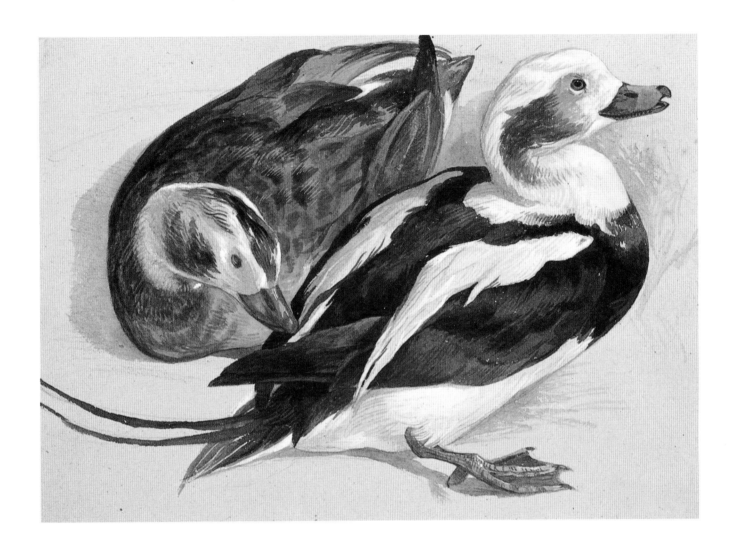

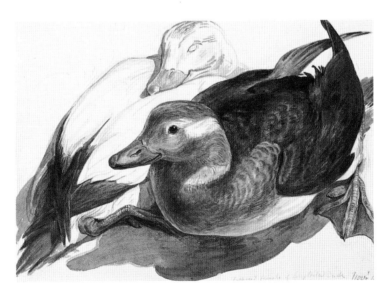

Supposed female of long tailed duck

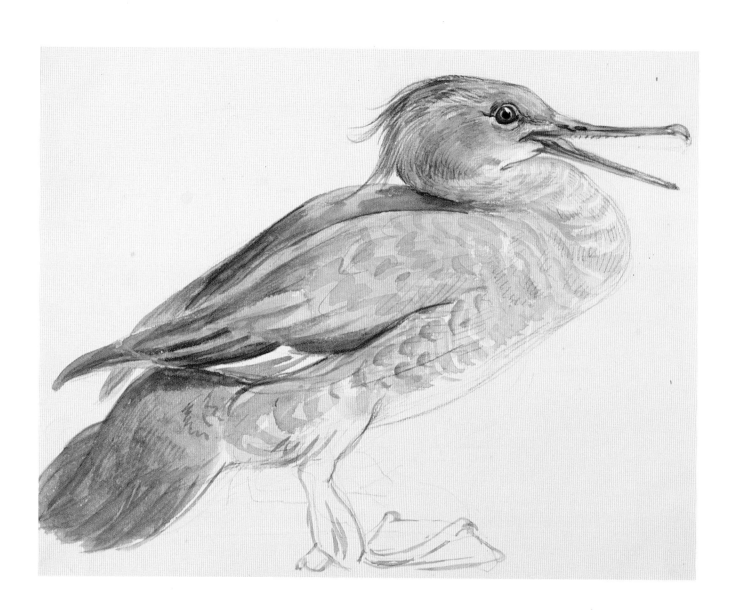

THE mother bird in this illustration was from a live one caught unhurt in its nest by a little dog. After being taken home and portrayed, it was let out of the window. The eggs of sea birds do not require to be so constantly sat upon as those of land birds. On a fine day the gulls are more often to be seen standing beside the nest than sitting on the eggs. In bad weather and at night they sit close, so I trust neither mother nor eggs were any the worse for her short sojourn in the studio.

The nest had a fishy fume perceptible at a distance. It contained eight or nine buff-coloured eggs, surrounded by a roll of rather dirty grey down. The nests are often placed on the top of a steep rock in a heathery place, whence the young must be helped down to the sea by their mothers, as they could not come down of themselves at so early an age. They follow her in the sea, swimming and diving with great activity almost as soon as hatched, sometimes running with great speed on top of the water with their disproportionately large webbed feet acting as a support like snow shoes, and leaving a white streak of spray behind them.

The adult has the eyes bright red; in the young they are blue. Young creatures, both bird and beast, have often blue eyes in their infancy, which turn yellow-red, or hazel afterwards; some hazel, which turn yellow. I do not know if eyes which are blue in the adult ever begin with a different colour. I have seen in old people with hazel eyes a blue or grey tint beginning round the outside edge of the dark brown iris, as if the colour were fading or turning grey like hair. The young hoodie crows that I have seen had blue eyes; the old ones have very dark hazel.

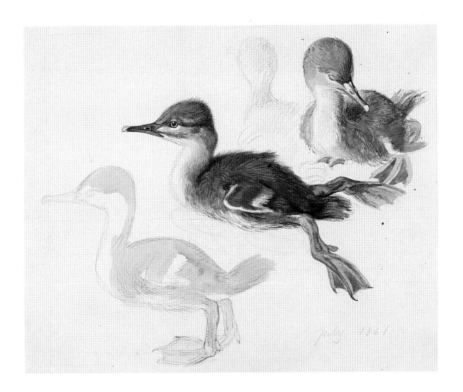

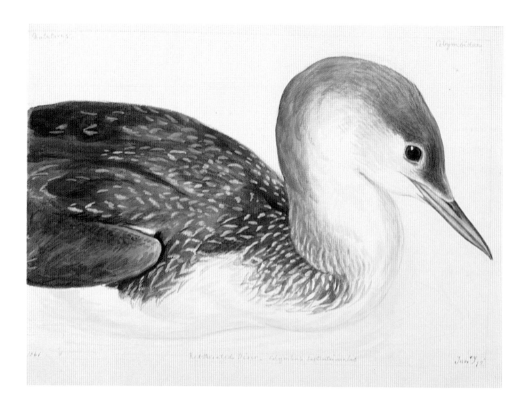

BOTH the Great Northern Diver and the Red Throated Diver come here in autumn and winter. They make a plaintive cry, something like the whinnying of a young foal. The diver breeds in freshwater lochs, among wild hills, in the north of Scotland. A dead young one was sent to me from Sutherlandshire. It was an ungainly little creature, covered with coarse black down.

One of the most interesting sights in the zoo is the feeding of the diving birds, in a large glass tank, in the aquarium-house. One can see their various modes of progression under water, in pursuit of the minnows thrown to them. The Guillemot uses both wings and legs at once, flying and swimming and steering with its feet. The Penguin uses its wings only for progression under water; they are not large enough to fly in the air with. It steers with its hinder end. It shines bright with air bubbles all over its body when it first plunges under water. The Darter, a most elegant slender bird of the cormorant species, uses its legs only in swimming under water. It moves fast and with great ease, catching fish most cleverly, reaching them with its long neck, which, however stretched out, seems always to be able to reach a little farther by relaxing a sort of kink in the middle of it. (Looking at them there is much more agreeable than having to follow a liberated Guillemot into the sea to find out if it really flies under water.) When the Darter has caught its minnow, it comes up to the surface, tosses up the fish and catches it again, so as to be able to swallow it head foremost, as the Kingfishers do; indeed, it would be difficult to swallow a fish whole in any other way.

THE Guillemot, though it frequents Loch Ailort in search of fish, especially herring fry, does not breed here. It prefers more precipitous rocks than are to be found here, such as the Bass or Barra Head, where the nearly perpendicular precipices are from 400 to 600 feet high, and where many kinds of sea birds rear their young on the narrow ledges of rock at a considerable height above the sea, choosing the elevation according to their several tastes – oddly enough, the small winged Guillemot choosing the highest ledge, where, exposed to the Atlantic storms, it lays its one or at most two eggs, which are of a large size in proportion to the bird. The Guillemot swallows the fish it catches, and when they are half digested, disgorges them for the young to feed on. The Guillemot I drew in summer plumage had the feet and legs black. Some we saw in January, in the Glasgow Market, had the legs and toes orange-yellow, membranes olive, claws yellow.

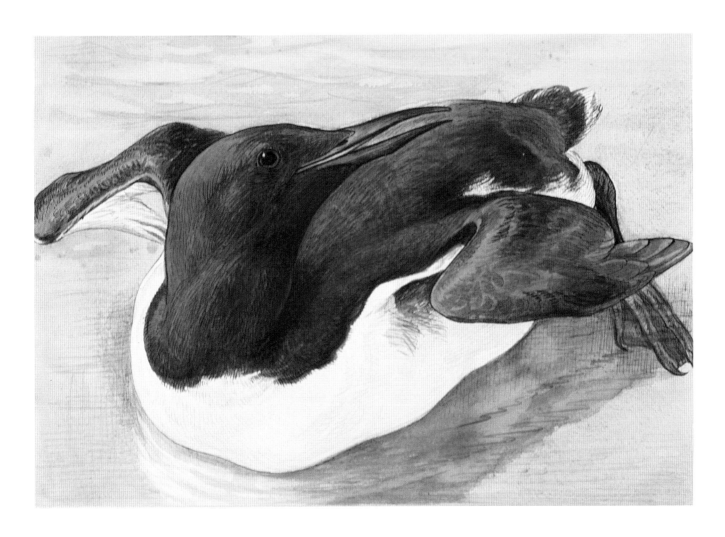

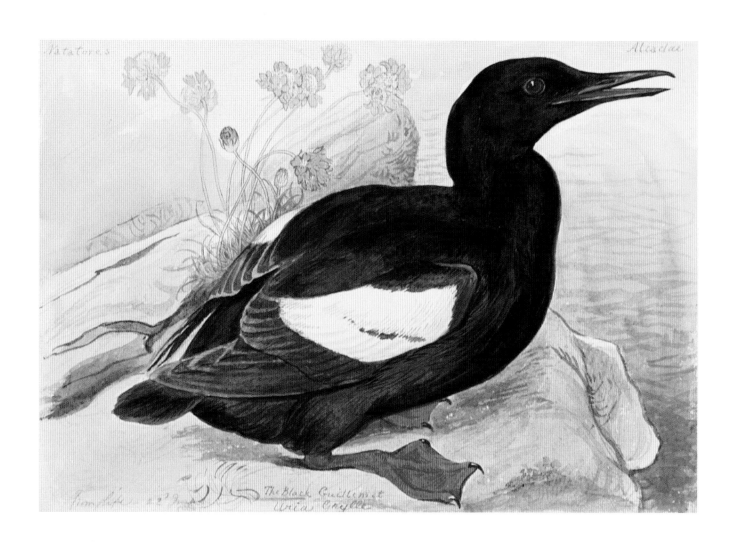

The Black Guillemot
Uria Grylle

THIS bird was caught alive on her eggs on a rocky island at the mouth of Loch Ailort, where a few pairs breed annually. She returned to her eggs – we cannot call it her nest – on being let out of the window after her picture had been taken. Unlike the Common Guillemot, the black one, when alarmed, readily flies up off the water instead of diving. The flight has a resemblance to that of the Grouse.

The specimen figured in winter plumage was shot, in October, in Loch-na-Nuagh [*sic*]. It is called the 'Dovekie' by Arctic voyagers, who find it a plentiful article of food. It is only in winter plumage that it has a remote resemblance to a dove. The young ones were drawn from life, and were not injured by the operation, being afterwards restored in safety to their nursery. So far as we have observed, it lays one or two eggs and no more; but sometimes the birds lay near the same place and get mixed.

Razorbills and Guillemots are common here, and Puffins are to be seen sometimes in the autumn. None of them breed in this immediate neighbourhood. They are difficult to shoot as they dive at the first flash of a gun. The Guillemot flies much better than one would suppose possible with such small wings. We had an excellent opportunity of observing the way in which it uses them under water, by letting away in clear, but not deep, water one which had been caught uninjured.

⊁ BRIDLED GUILLEMOT ⊁

THE ringed or bridled Guillemot whose head is shown in the drawing was shot on the Clyde, near Greenock. We have also seen one here.

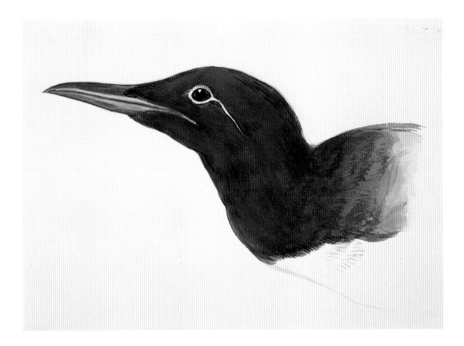

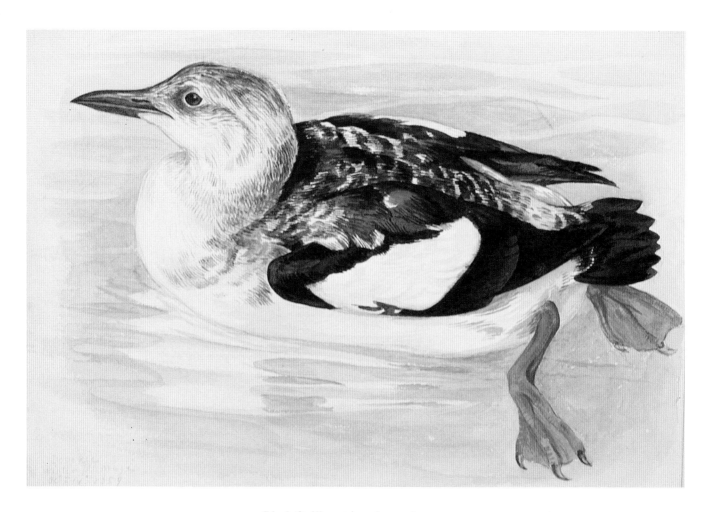

Black Guillemot in winter plumage

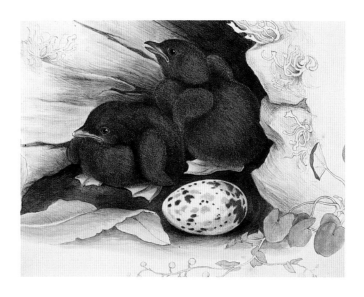

Black Guillemot chicks

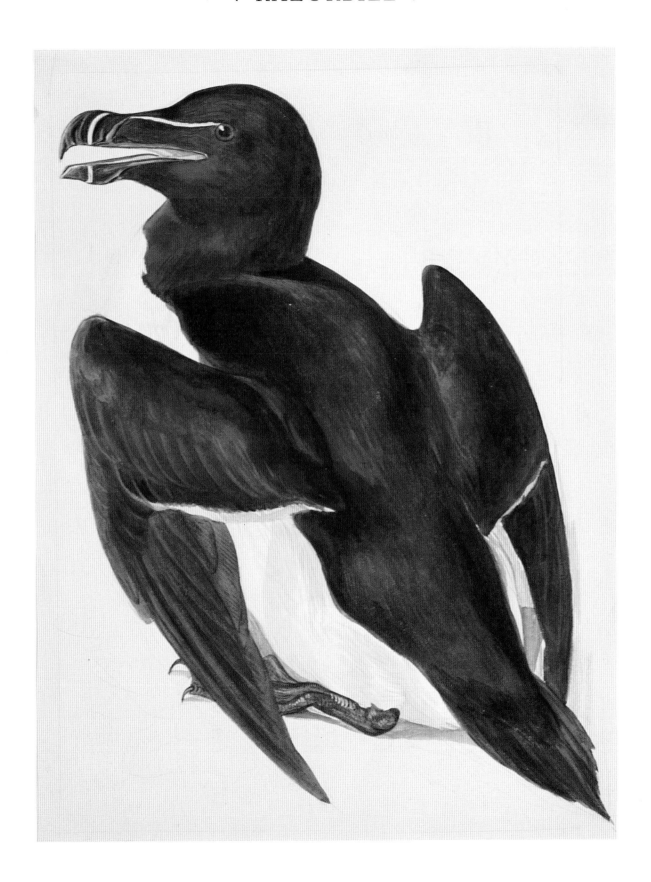

DRAWN from life in the Zoological Gardens. A gentleman was trying at the time to photograph them, but they fidgeted too much. It was before the kodak [*sic*] had come into use. So my drawing was made use of at a meeting of the Zoological Society.

JUNE 6, 1882 PROFESSOR FLOWER LL.D. F.R.S., PRESIDENT, IN THE CHAIR
The secretary called attention to the curious way in which the young Cormorants, lately hatched in the Gardens, were fed by the parent bird, and exhibited a drawing by Mrs Hugh Blackburn, taken on the 9th ult., illustrating this subject. The Cormorants deposited by Captain Salvin in the autumn of 1881 had paired in March last, and built a nest of sticks on a stump in the enclosure called the 'Gull Pond'. Two young ones were hatched on the 22nd April last, after four weeks' incubation, both parents taking turns in the nest. The young birds were at first naked, but soon became covered with black down-plumage, whence they were now beginning to moult into their adult dress. As would be seen by the illustration, the parents fed the young ones by allowing them to poke their heads far down into the parents' throats and to extract the semi-digested fish from the stomach.

Captain Salvin used to keep Cormorants trained for fishing. Unluckily they died before I had an opportunity of seeing them at work. They are now beautifully stuffed, and set up in the Hancock Museum at Newcastle, with the little leather collars round their necks to prevent them swallowing the fish they caught.

There are many Cormorants here in the autumn. They abound in the island of Heiskar, where there must be a great supply of fish to support both them and the numerous seals that frequent it. Cormorants build on the ledges of high rocks at the Land's End in Cornwall and on the cliffs in Barra.

THE bird from which the head of the Solan Goose was drawn, was found quite recently dead on the shore near the mouth of Loch Ailort, where we frequently see a few in Autumn or in rough weather. They probably come from Ailsa Craig, as their is no place nearer here where they congregate or breed. There is a colony of them on the Bass Rock, which is the best place of all for seeing their nests. Such persons as cannot get there may see the scene admirably represented in the Natural History Museum in Cromwell Road. The first plumage of the Solan Goose (which it retains for, I believe, two years) is dark brown, spotted with white. It is a mystery to me where they spend their adolescence, one so seldom sees them anywhere, not even near the Bass Rock or Ailsa Craig. All I have seen there have been white. The only one I ever saw in full brown plumage was in the Bay of Biscay, on a very stormy day in October. I have occasionally seen one not quite white, but with some patches of brown still remaining.

We conjecture that this bird, and others which we have found in similar circumstances, had been killed in plunging from a great height into the sea, as these birds do when fishing.

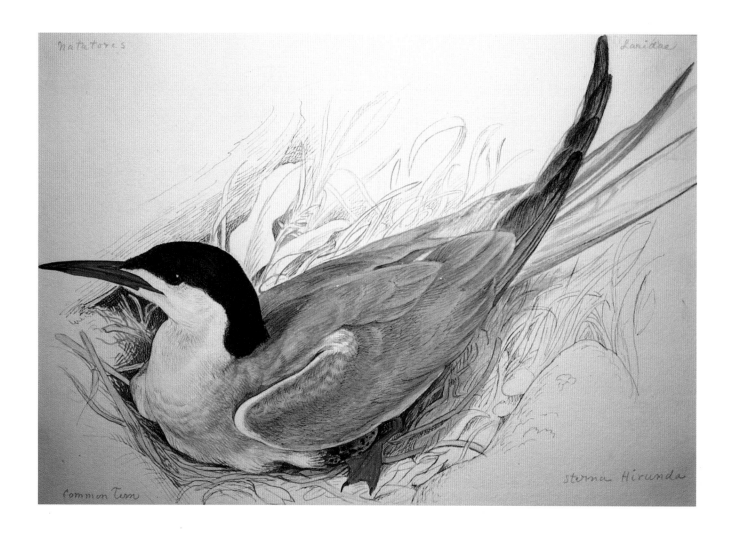

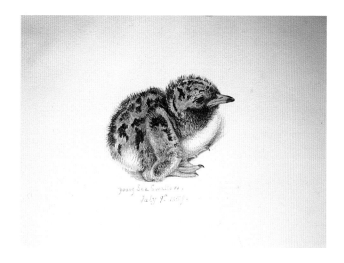

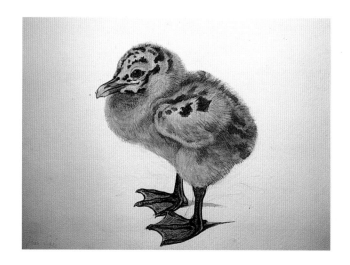

Young Tern *Young Gull*

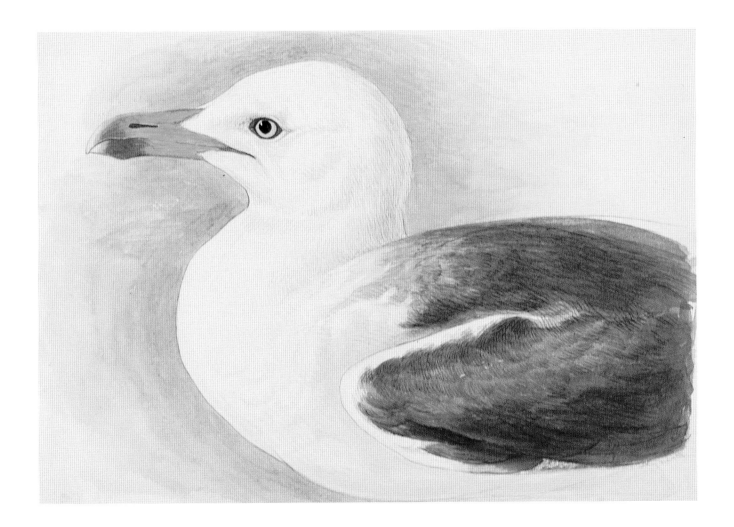

THE figure in the above plate is from an adult Lesser Black-Backed Gull. The young Gull, whether Herring or Black-Backed, in the course of a few weeks changes his downy coat for the mottled-brown plumage represented to the left of this plate. This plumage is retained for at least one year, and the young birds of the two species, as well as of the Great Black-Backed Gull, the plumage of which passes through corresponding changes, are often mistaken for distinct species from their parents. In former times, when natural history was not so much studied as it is now, the young Herring Gull was supposed, from the dissimilarity of its plumage, to be of a different species, and was called the 'Wagel' or 'Burgomaster'.

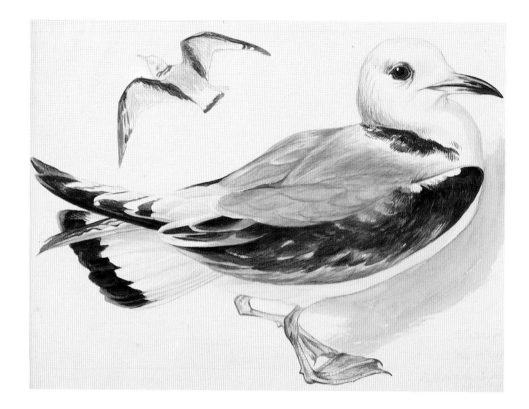

THE young Kittiwake, in the first year, has part of the wings and back dark, and a dark ring round the back of the neck. It used to be called 'Tarrock', and was supposed also to be of a different species. It is like a Common Seamew, but has no hind toe – only a small excrescence; also, instead of the Seamew's inarticulate scream, its cry is distinctly 'Kittiwake'. There is another distinguishing mark which has not been noticed in any description – a red patch at the edges of the gape and the base of the lower mandible.

The Kittiwake builds on the highest ledge of the high cliffs at Barrahead [*sic*], and in the westmost islands; the Seamew on quite low rocky islands in the upper part of Loch Ailort. Most young gulls are brownish and speckled at first – a less conspicuous colour than the white and light grey of their maturer years, and more suitable in the helpless stage of youth, when concealment is their only safety. The young Tern has its first feathers edged with drab colour, and its beak and feet pale orange; not the brilliant scarlet they afterwards become. The fact of the young offspring being so differently coloured from their parents occurs among beasts as well as birds. Young wild boars are striped, while the old ones are plain brown. A young Tapir I saw in the Zoo, which had been born there, was striped very like them, while its mother was plain grey. The young of the red deer and the roe are both spotted with white, like the fallow deer. Foxes are born black; so are tigers.

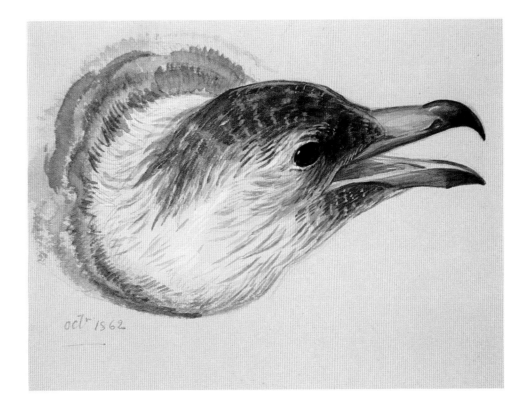

ONE day when I was out fishing I saw what looked like a Hawk in pursuit of a Sea
Gull, which was evidently in great fright. To my surprise the dark coloured hawk-
like bird soon after alighted on the sea, and swam about among the other Gulls. An
old fisherman who was out with me told me in such English as he could command
that it was a sort of Gull that chased the others and stole their fish, so I conjectured
that the bird I saw must be the Skua, which I read of, but had never seen. It dashed at
the Gull, which opened its beak to scream, dropping the fish, which the Skua caught
in mid-air, and carried off.

Gulls have not the powerful flight of the Gannet to enable them to battle with the
fury of the winter blasts. On the approach of a storm they often fly inland for many
miles and feed on the insects and worms they find in the ploughed fields. I have seen
them here taking refuge from a winter gale, all huddled together in a sheltered corner
of a partly submerged field near the sea, quite unable to fly. Among them were some
Skuas in a helpless condition, one of which we managed to catch. On comparing it
with Yarrell's description we believed it to be Richardson's Skua. It was speckled
brown of a lighter colour than the Common Skua, its eyes and beak were dark, and
its legs pale coloured, with dark toes and webs.

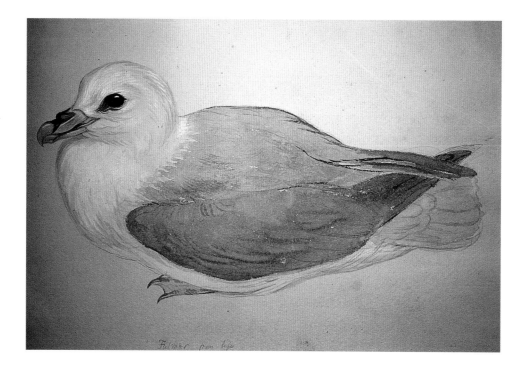

THE drawing of the Fulmar is from a live one brought from St Kilda by a yachting friend. It was done life size. It is much like the Herring Gull, the same in colour, but not quite of so handsome a shape but has a very peculiar beak, with the nostrils in a tube. We saw numbers of them flying about near St Kilda, where they inhabit the high cliffs, and serve, when smoked and dried, as winter food for the natives, as well as for furnishing oil for their lamps. There were many near some similar islands on the coast of Iceland, and near the Faroe Islands, where there were also crowds of Guillemots and other sea-birds. It was very foggy on the day we approached those islands, but one could guess where the land lay by seeing the birds fly in that direction with fish in their bills.

The first time I ever saw the Storm Petrel was in a great gale, on the 3rd October 1860, when some of them were blown inland over the top of the house. We mistook them at first for Swallows, and wondered at their being here so late. I have seen specimens in the island of St Kilda captured by the natives, and offered to us for sale. I have no doubt they breed there, but we had no time to go in search of them, being on our way to Iceland. We feared that if the wind rose we might be storm-stayed there, for when the sea is rough, neither landing nor embarkation is possible, as there is such a swell on the rocks of that unsheltered shore.

The Petrel, Fulmar, and others of that kind are well supplied with oil, which they squirt out of their peculiarly formed beaks, as a defence against their enemies. Is it possible that they may use it to calm the stormy waves, as ships do?

THE Shearwater is to be met with here on the open sea, between the coast of Moidart and the island of Eigg, where it is said to breed; as also on the Isle of Man, whence its name, 'The Manx Shearwater'. The illustration is done from a disabled specimen we picked up while yachting, which, after being sketched, was let go. I have seen many such birds in the Mediterranean flying low, just over the tops of the waves. Among the French sailors they go by the name of 'Ames Damnées'; wherefore, I do not know; perhaps a survival of the doctrine of transmigration of souls.

Major-General Richardson tells me that long ago, when he was shooting on the Pontana marshes in Sicily, there used to be a lot of Terns, which fluttered about, and that Mario, his factotum, a superstitious Sicilian, said they were 'the souls of the dead', and did not want him to shoot any of them.

A Sicilian friend also writes me that a Tern, which he calls *Sterna fluvialis*, is to be found on these marshes, and is called *Ame de Sbirro*.

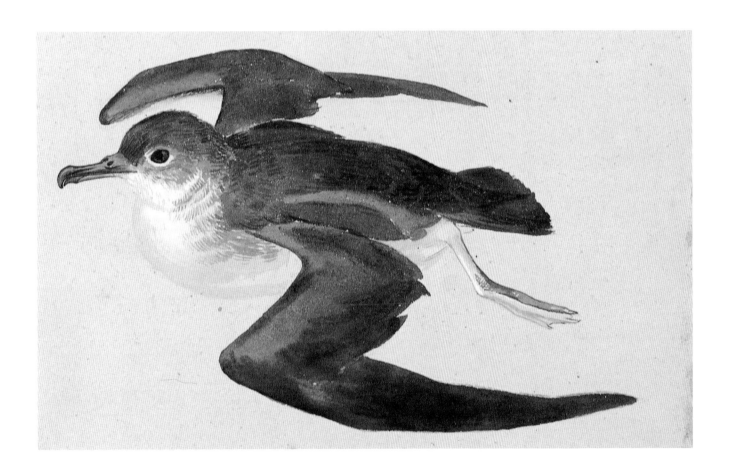